Quilt National
2009

Quilt National
2009
The Best of Contemporary Quilts

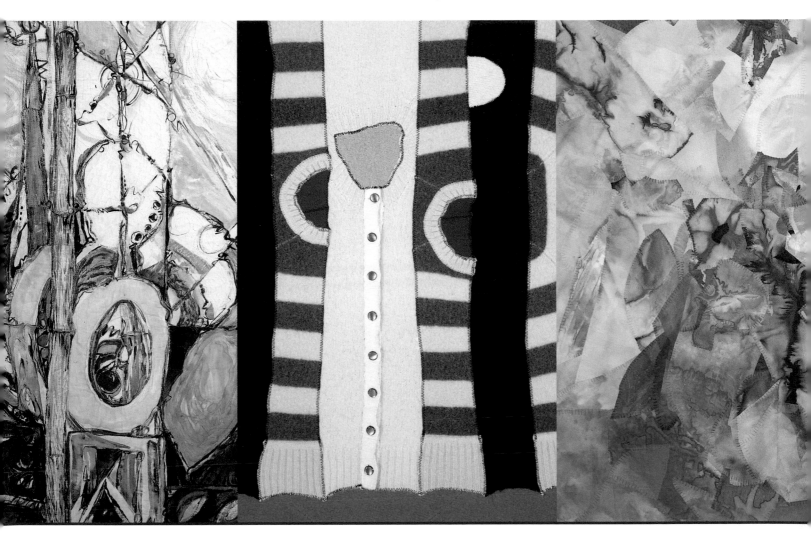

More Than 80 Inspiring Creations

Co-produced by
Lark Books &
The Dairy Barn Arts Center

LARK BOOKS
A Division of Sterling Publishing Co., Inc.
New York / London

Quilt National Director
Kathleen M. Dawson

Senior Editor
Valerie Van Arsdale Shrader

Editor
Susan Mowery Kieffer

Art Director
Kathleen Holmes

Photographer
Brian Blauser

Cover Designer
Kathleen Holmes

Art Production Assistance
Jeff Hamilton

Editorial Assistance
Gavin Young
Dawn Dillingham

Editorial Intern
Maggie Alvarez

Art Intern
Kelly Stallard

Cover: **Paula Kovarik**, page 22

Front flap: **Pam RuBert**, page 85

Title page, left to right:

Sandra LH Woock, page 80
Ellen Zak Danforth, page 103
Emily Richardson, page 87

Contents page: **Linda Colsh**, page 47

Back flap: **Marianne Burr**, page 24

Back cover:

Anne Smith, page 83
Erin M. Wilson, page 76

Library of Congress Cataloging-in-Publication Data

Quilt National (2009 : Athens, Ohio)
 Quilt National 2009 : the best of contemporary quilts / co-produced by
Lark Books & the Dairy Barn Arts Center. -- 1st ed.
 p. cm.
 Includes index.
 ISBN 978-1-60059-423-6 (hc-plc with jacket : alk. paper)
 1. Art quilt—United States—History—21st century—Exhibitions. 2. Art
quilts—History—21st century—Exhibitions. I. Lark Books. II. Dairy Barn
Southeastern Ohio Arts Center. III. Title. IV. Title: Best of
contemporary quilts.
 NK9112.Q5 2009
 746.460973'07477197—dc22
 2008051296

10 9 8 7 6 5 4 3 2 1

First Edition

Published by Lark Books, A Division of Sterling Publishing Co., Inc.
387 Park Avenue South, New York, NY 10016

Text © 2009, Lark Books
Photography © 2009, Lark Books, unless otherwise specified

Distributed in Canada by Sterling Publishing, c/o Canadian Manda Group,
165 Dufferin Street
Toronto, Ontario, Canada M6K 3H6

Distributed in the United Kingdom by GMC Distribution Services, Castle Place,
166 High Street, Lewes, East Sussex, England BN7 1XU

Distributed in Australia by Capricorn Link (Australia) Pty Ltd., P.O. Box 704, Windsor,
NSW 2756 Australia

If you have questions or comments about this book, please contact:

Lark Books
67 Broadway
Asheville, NC 28801
828-253-0467

Manufactured in China

ISBN 13: 978-1-60059-423-6

For information about custom editions, special sales, premium and corporate purchases,
please contact Sterling Special Sales Department at specialsales@sterlingpub.com. or
800-805-5489.

Contents

FOREWORD

This is the 16th biennial, international, juried exhibition of Quilt National. The exhibition began as an opportunity for contemporary quilt artists to exhibit their work and has evolved into an internationally recognized and respected exhibit for this medium. Quilt National '09 marks the 30th anniversary of what was considered a groundbreaking exhibition in 1979—an exhibition that embraced the departure from the traditional past, and an exhibition that continues to foster artistic innovation and diversity in the contemporary quilt world.

On behalf of the entire staff and board of trustees, I would like to extend our gratitude to the businesses, organizations, and individuals whose generosity in time and financial support make it possible for the Dairy Barn Arts Center to produce this exhibition that showcases the work of some of the most talented, professional and emerging artists working in the medium. An exhibition like this is not possible without the contributions and insight of many individuals. The corps of volunteers, jurors, and artists were guided by Kathleen Dawson, Quilt National Director, who continues to promote this exhibition and encourage the artists who make it a reality.

Works in fiber are not meant to be experienced in two dimensions. Works in fiber are intended to be experienced first-hand to allow the viewer to discover the nuances in surface texture and variations in color, and to appreciate the details articulated in stitches. This catalog is a printed record that documents the exhibition in its entirety and illustrates the diverse methods and processes of artists working in the medium today. Over the past three decades, Quilt National has included more than 1,300 works from artists, many of whom were pioneers in the contemporary art-quilt movement and many who continue to reveal new directions in the medium.

This year more than 1,000 works were submitted by artists from 46 states and 20 foreign countries for the opportunity to be chosen for Quilt National '09. These artists represent the foundation of what Quilt National is as well as the future of the art-quilt medium. It is these artists who create new and exciting work, who painstakingly prepare their entries each year, and who have solidified the reputation of the Dairy Barn Arts Center and Quilt National, both in the United States and around the world.

Andrea Lewis
Executive Director
Dairy Barn Arts Center

Major support is provided by:
Fairfield Processing
Friends of Fiber Art International
Husqvarna-Viking Sewing
 Machines
The James Foundation
The Ohio University Inn and
 Conference Center
Quilts Japan Magazine/Nihon
 Vogue Co., Ltd.

Additional support comes from the following businesses and organizations:
Aaron's
Athens County Convention and
 Visitor's Bureau
Hampton Inn
Honeyfork Fabrics
Nelsonville Quilt Co.
Ohio Arts Council
Ohio Quilts!!
Porter Financial Services
Studio Art Quilt Associates, Inc
Sulky of America

And the following generous individuals:
Betty Goodwin
The McCarthy Family

INTRODUCTION

Quilt National '09 celebrates the 30th anniversary of the Quilt National Exhibition. I doubt that any of the original organizers of that first exhibition in 1979, nor any of the members of the Hocking Valley Arts Council who were responsible for "saving" a 66-year-old, abandoned dairy barn from demolition in 1978, could have even imagined this legacy that was born of frustration and vision. Quilt National, which has always been an international exhibition, and was perhaps misnamed early on, was born at a particular point in time, when the needs of quilt artists who were ready to move beyond the constraints of the traditional quilting world coincided with the need of a newly established arts center to host an inaugural exhibition.

The emerging fiber art form known as the "art quilt" was pushing the boundaries of traditional quilting and gaining popularity as a form of expression and popularity with a wide audience of viewers. Thus, the collaborators of the first Quilt National—François Barnes, Nancy Crow, and Virginia Randles—happened to be gathered in Athens, Ohio, in the late 1970s, and the Dairy Barn Arts Center happened to be looking for its premier exhibition, and the result is what has been dubbed "the big bang" of the art-quilt world, and Quilt National was born. The success and longevity of this exhibition can be attributed to the persistence of the staff of the Dairy Barn in Athens, Ohio—most notably longtime Quilt National Director, the late Hilary Morrow Fletcher—as well as the appeal of the medium itself, both to the artists who have embraced it and to the public that supports it in growing numbers.

This medium continues to attract and nurture new artists, new support organizations, and new public awareness around the world. While the early Quilt Nationals were a departure from the traditional quilt shows of the 1970s and today, there were many recognizable elements of composition and form. The more recent Quilt National exhibitions have truly crossed into a different realm that begins with the concept of the art. That concept is then developed through the use of fabric and thread, combined with all manner of fabric manipulation—printing, painting, embellishing, incorporating digital imagery, any number of methods of dyeing, and techniques that have yet to be discovered. As a silent observer of the jurying process in September, I came away with the impression that the jurors considered each entry first as a piece of art and second as a quilt. Was it something new and unique? Was it yet another rendition of something that had been done before? Did it go in a direction different than work of a particular style had gone before?

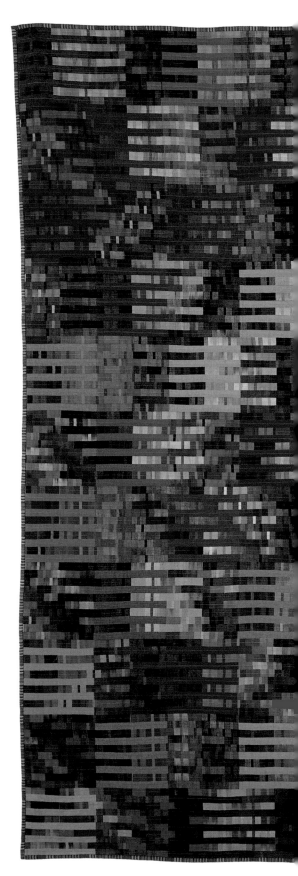

Kent Williams
Take Five
(detail)

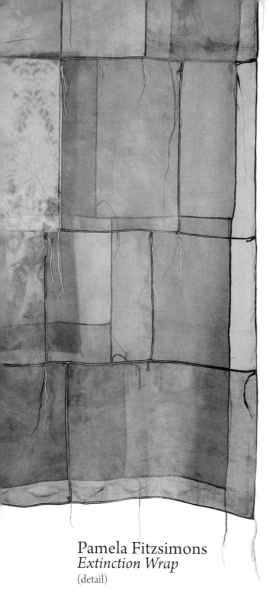

Pamela Fitzsimons
Extinction Wrap
(detail)

When Quilt National was first conceived in 1979, its purpose was to provide a venue for a medium that had no venue in the quilt world or the art world. Over the past 30 years there has been an ongoing commentary that seeks to move the medium into the world of fine art and blur the distinction that moves from quilt to art quilt to art. Everyone has, and is entitled to, his or her own opinion as to how that should or could be. We at the Dairy Barn Arts Center will continue to persist in our efforts to bring the newest, most innovative works to the attention of the world. It is a big job, but we are delighted to uphold the tradition that began as a rebellion to the traditional perspectives on quilting. We will continue to look for and encourage new techniques and uses of new media, while paying the appropriate homage to the roots of the movement and the many unheralded artists who are part of its history.

The 2009 Quilt National exhibition presents 87 new and unique works for public display. The 85 juried works represent artists from 25 states and 13 foreign countries. This is the highest-percentage representation of work from outside of the United States in the history of Quilt National. Of the 85 works, 48 percent of the total works represent artists who have never shown previously in Quilt National. We like to interpret this statistic to mean that Quilt National will continue to attract new artists, and the medium will continue to grow in new, varied, and intriguing directions. It is as exciting to see new and emerging artists as it is to watch the growth of established artists as they move in new directions.

Finally, I would like to express my gratitude to all of the individuals who come together to make the process of producing Quilt National possible—the Dairy Barn staff, members of the Dairy Barn Board of Trustees, and the many community members who volunteer their time and effort to make the selection process proceed as smoothly as it does. I would particularly like to thank our panel of jurors—Sue Benner, Katie Pasquini Masopust, and Ned Wert. Their concentrated efforts and artistic insights are greatly appreciated. And, of course, I need to say a special thank you to the two gentlemen who have tamed the technological side of the process—Marvin Fletcher and Ron Dawson. Without their very generous donation of time and expertise, the technical aspects of the presentation and data management during the jurying process would not have been handled as capably or professionally.

Kathleen M. Dawson
Quilt National Director

Sue Benner

First off, let me admit that I am a novice juror. As an artist, I tend to keep my nose to the grindstone in my studio. I've been successful enough to be able to do this for a long time now—since 1980. When I'm not working, I tend to my two teenage boys and my husband. If I am away from my studio and family, I'm probably teaching a workshop or attending a reception for an exhibition. While this activity feeds my ego, the work in my studio is what feeds my soul; it is crucial to my being. Making things, especially art and quilts, soothes my prickly self.

When Kathleen Dawson, Director of Quilt National, approached me about jurying *Quilt National 2009*, I felt profoundly honored. That feeling lasted about five minutes,

and then other emotions—anxiety, doubt, and dread, to name three—took its place. When I learned that Katie Pasquini Masopust and Ned Wert were the other jurors, though, I relaxed somewhat. While I might be anxious, I knew I'd at least have a good time!

The opportunity to review a thousand-plus quilts was thrilling, and the process of jurying was fascinating. The Dairy Barn staff and volunteers worked hard to make the process as smooth for us as possible. Ned, Katie, and I viewed images on a large-screen HD television over a period of a few days. As we worked, I was amazed how some works held our attention the entire time, while others rose to the top gradually, upon multiple viewings. A

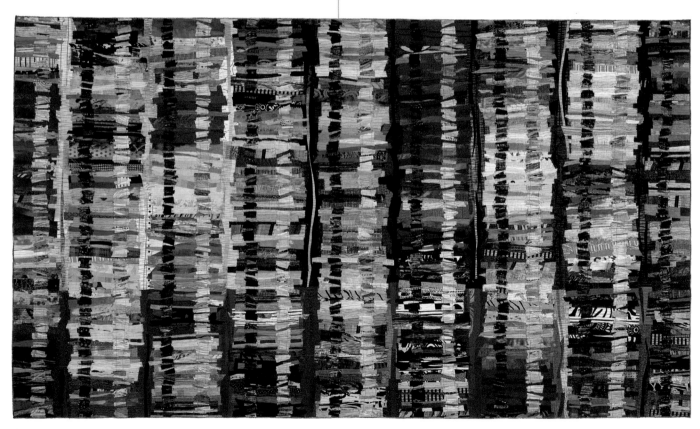

Sue Benner
Display II
2008

Cotton, silk, found fabrics, dye, paint, hand-dyed cottons by Judy Bianchi, Carlene Keller, Heide Stoll-Weber, Helene Davis, and Cherie St. Cyr; dyed, painted, monoprinted, fused, machine quilted

76"W x 45"H (193 x 114 cm)

While enjoying time in a quilt shop last year, I came upon a large rack of embroidery floss and was stunned by its visual strength. It reminded me of my joy as a young girl, buying hanks of this same thread at the Ben Franklin five-and-dime store, carefully choosing colors for my latest sewing project.

few quilts we immediately agreed on. Others had staying power because two or even just one of us felt strongly about them. We challenged each other and defended our choices. It was a raucous time.

This was the first time that Quilt National had asked for images to be submitted in digital form. While I'm sure some entrants thought it was about time, others apparently found the switch from transparency film overly complicated. It's true there are issues, but time and technology march forward. Pixels and LCD screens have become the standard for transmitting and receiving visual information.

It has always been true that some art quilts translate into the medium of photography better than others. In some cases, photography enhances the image beyond the original artwork. In other cases, even good photography can't capture a work's color effects or subtle textures. In addition, digital images can be modified easily with common software, which raises concern, as does the lack of color consistency. On the other hand, sorting digital images is much more convenient, and the flexibility of a digital slide show provided multiple ways to view and compare the quilts.

Looking back at the days we spent jurying, I have some observations and suggestions for anyone who is considering submitting their work to Quilt National in the future:

• When making our choices, we could only select from the artists who had followed the submission rules. Moreover, we could see only what was in the photograph and could know only the information written on the entry form. When making a submission, please read and follow the rules. All juried exhibitions, especially medium-specific exhibitions, have rules for a reason. Don't let a publishing issue stand between you and acceptance. Remember the Internet is a publishing medium as well as a powerful search tool.

Sue Benner
Display II
(detail)

• Take excellent photographs or have them taken by a professional. Make sure the photos show the essential qualities of the work. Employ detail photos to actually show the stitching and/or assembly. This is especially important to us as jurors when we're trying to decipher the "quiltness" of a work—why it is a quilt and what it might look like if viewed in person.

• Research how the jury will view the image, and then preview your image in a similar manner. Write clearly on your entry form. Provide information that will help the jurors understand the work.

• This advice goes without saying, but I'll say it anyway: Create excellent and ambitious work. Then, submit it!

Quilt National began as a showcase and venue for the latest and most challenging work in the quilt medium, even before

the term "art quilt" was coined. At that time, there were very few venues to even show work of this kind. Now we discuss and debate the quilt as an art medium with its own formal considerations, and many opportunities exist for exhibition.

When I teach workshops and attend openings, the discussion often turns to the current and future state of this medium. Is the art quilt progressing? How does it relate to other media? Does it fit into the mainstream art world, and should we care? Can it hold a wealth of expression? Does it hold us back in any way?

Art quilts can't merely imitate other art. Some quilts get attention just because of their inherent cleverness—I bet you didn't think I could do this in fabric, did you? Work that's unique only because it's made of fabric and stitching will have a limited shelf life. There is also the question of digitally printed fabric. Can a quilt made from it be a print on paper just as well, with little difference in the viewing experience?

The form and materials have to say something. Why is this a quilt? Does it matter that it's made out of fabric? Does the stitching add another artistic layer? Does it have integrity as a whole?

The surface and structure of a quilt can accommodate many approaches to image and object. Piecing allows juxtaposition of color and pattern with the lovely, indented line between them. Textiles can be layered in appliqué and collage, building complicated relationships. Found fabrics can be used in much the same way as found objects and ephemera. Surface design is imbedded in the fabric itself, and painting and printing give additional layers of depth. Stitching and other ways of connecting the fabric layers add pattern and texture. The quilt floats somewhere between surface and object; it can be explored as a relief sculpture or topographical map.

Quilters are exploring alternative or mixed media, using textiles, collage, layering, and even stitching. Are we, as artists, looking at this and comparing the strength of our work? Is there really a problem with being accepted by the so-called mainstream art world? Whining that we are misunderstood won't get us very far. We have an insular community, and it is often a self-congratulatory, mutual-admiration society. We say we want critique, but do we really? I am sure we can still have fun, provide support for each other, be really nice people, and produce challenging work.

Here's my advice to my fellow quilters: Get outside your medium. Exhibit and sell your art! Work inside to improve your craft, but expand your ideas and cross more boundaries. Meet and associate with other artists. Experiment with other media and bring new ideas back to your quilts. Encourage other and younger artists to explore new ways of making things. Become their friends. Teach the young'uns to sew!

Most importantly, make bold and daring work. Make a lot of it. And, at least some of the time, make it large. (A note about size: A large work in itself is not necessarily good art, but a large quilt that is also really good can be a very important piece of art. Large work demands attention. Ned, Katie, and I all wanted to see larger art quilts.)

After all the excitement of the jurying weekend, anxiety has returned. I feel humble, wondering if the job Katie, Ned, and I did will meet our expectations on the printed page. I expect excellence. I want to see work that aspires to devastating beauty, to daring content. I want work that draws me in and allows me to explore its universe. Anxiously, I look forward to seeing the show. I hope you do too.

Thank you to everyone who submitted work, and thanks to the Dairy Barn Arts Center and their continued support of Quilt National.

Katie Pasquini Masopust

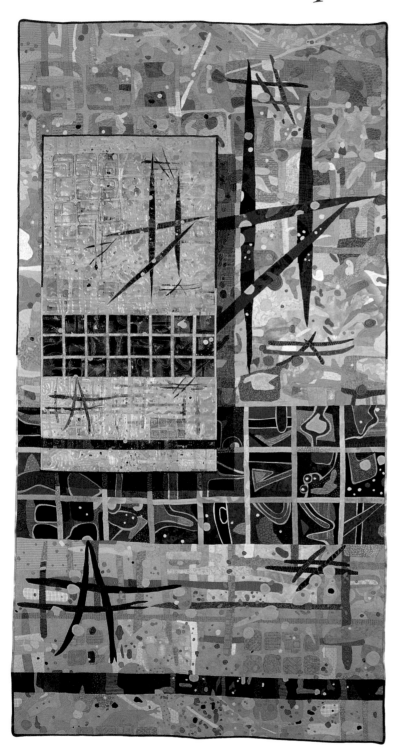

A musical painting, surrounded by a fabric chorus. I have returned to my roots as a painter, enjoying painting quickly with acrylics, using many layers to create depth. I can't stay away from fabric for long, so the painting was repeated, as a chorus, in fabric.

I've always wanted to be on the jury for Quilt National. During my term as president of the Studio Art Quilt Associates, I was present at SAQA's mini-conferences held in conjunction with Quilt National openings. The highlight for me was attending opening night, all dressed up to visit my friends. I marveled at the art quilts covering the walls of the Dairy Barn Arts Center. I envied the jurors for the fascination they must have felt as they reviewed all the submitted images, though I sympathized with them about the difficulty of having to select only enough to fit the size of the Dairy Barn Arts Center. I fantasized about being on that jury and working with Hilary, Marvin, and the Dairy Barn staff.

Then it happened! At a dinner during the Quilt National opening in 2007, I was asked to be on the 2009 panel. I was thrilled, my fantasy come true! Only Hilary Fletcher—the most important champion of the art quilt movement—would not be there, for she had passed away the year before. She would be missed, but I knew that Marvin and the staff would carry on the tradition for her. Later, I was delighted to learn I'd be jurying with Sue Benner and Ned Wert. I'd worked with both of them before, on other projects, and I admire them and their work immensely.

I was impressed with all the new technology we used for the jury process. A big round of applause for the technical skills of Ron Dawson, who put all the images into a smooth digital slide presentation. When the photography was good, the technology showed the images to their best advantage. When a bad image popped up, however, it looked even worse than if it had been a bad slide. Let this be a

Katie Pasquini Masopust
Allegretto
2008

Cotton, cotton blends, canvas, synthetic suede, acrylic paint; painted, appliquéd, machine quilted

37"W x 72"H (94 x 183 cm)

warning to anyone entering this show: Have your digital images taken by a professional photographer who knows how to size your images to the specifications of the prospectus so they display well on a big screen.

Each juror scored on a separate list. After a silent round of viewing and scoring more than 1,000 entries, the staff used the lists to eliminate the images all three of us agreed to remove. Then we saw the "keepers" for another silent round of scoring. Only when we had pared the list down to a manageable 150 pieces or so did we start to discuss our thoughts with each other about the works.

I was pleased to see a great range in ideas and techniques. Some pieces—such as Patricia Goffette's *Haywire*, Jen Swearington's *The Sea Dream*, and Cathy Jeffers' *The Artist and the Mermaid*—were unlike anything I had ever encountered before. I was also impressed that many artists entered three very strong pieces for us to consider. The three pieces together got my attention, especially if the work displayed a strong exploration of a theme and technique.

We eliminated some pieces in the first round simply because the image wasn't clear. We eliminated others because we felt that we had seen them before—images were not supposed to have been published anywhere before this prestigious show. There were some pieces we hadn't seen before but felt as if we had. That was an indication to us that the artists were doing good work, but not changing and growing with their explorations.

Size was an issue. When looking at the images on a large, flat-screen TV we couldn't tell how big the quilts were, so we had to rely on the stated size of a piece on its entry form. When choosing works, we had to consider the space in which the work would be displayed. In the Dairy Barn Arts Center, which is very large, small pieces would be lost in the mix. We included Lora Rocke's *Kathryn, Kathy, Katie, Kate* because, although it's a small piece, the face of Katie so fills the space that it appears huge. In contrast, we included Kathleen Loomis' *Memorial Day* because it needs to be very large in order to hold all of the little flag souls.

I want to thank my dad for inspiring me to ask questions. When I was a little girl and he did or said something I didn't understand, I'd ask him, "Why did you do it that way?" or, "Why did you say that?" He would always respond, "To make little girls like you ask questions." That idea has stuck with me my whole life: to make people ask questions. I don't like the obvious solution to any problem, which is why I'm drawn to many of the quilts in this show. Something about them made me want to stop, take a second look, and ask, "How did they do that?" as in Sue Akerman's *Africa Scarified IV*, Alison Schwabe's *Timetracks 7*, and Jessica Jones' *Ruffled*. Other works raised the question "What's the story being told?" as in Glenys Mann's *Horizons #61: Memorial*, Shawn Quinlan's *God Bless America*, and Leisa Rich's *My House Is Built on Sand*. "Where did they come up with that idea?" inspired selections like Ellen Zak Danforth's *Parallel Bars* and Aaron McIntosh's *Communicating with the Past*. I'm impressed that there are so many ways to express oneself through cloth. This medium is so diverse and rich.

When all was said and done, we sat back and reviewed our selections one last time. Over half the show was submitted by first-time entrants. Excellent! That meant there is new blood out there, and the art-quilt movement is growing. It's now a totally international show with over 15 percent from outside the United States. Several pieces were made by artists we knew but did not realize they had made the work. This fact revealed that artists were changing as they continued their artistic process, reinventing themselves to keep their art interesting. It bodes well for the future.

We hope the pieces we chose for the show will make you stop to take a deeper look. I hope you'll ask questions about the composition, content, and techniques of construction. You probably won't love every piece in the show, and that's all right. Our intent was to encourage everyone to stretch the boundaries of art quilting and to keep this fantastic medium growing and expanding.

Ned Wert

It is always a pleasure to see works of art from an exhibition as professional as Quilt National is, and I was eager to arrive in Athens, Ohio, and begin the tough task of making preliminary and final decisions for Quilt National 2009. We were three artists judging art, and our combined efforts created what I regard as a very strong show that credits previously exhibited artists and discovers new ones.

There are five viewpoints to be realized:

Jurors are assigned the task of selecting not only challenging work but also "designing" an exhibition that illustrates artistic and original approaches from national and international artists. Each juror was selected because of personal expertise and a demonstrated openness to solutions within the media of fiber. What we searched for was art. Art may be defined in several ways, but we jurors carefully considered the more than 1,000 entries and made decisions that satisfied all three of us. I am happy to say that there was no competition among the jurors themselves, and the final selections were arrived at through professional and unified concerns. But, jurying the show is just one of the components that come together to produce a successful exhibition.

The Dairy Barn Arts Center, host organization of Quilt National, has developed a method for accepting images of work from all over the world. At this established venue for presenting one of the world's most prestigious art-quilt shows, the folks at The Dairy Barn Arts Center eagerly wait to see fresh, new work, knowing that there will be more entries than can be physically exhibited. As difficult as it is for all involved, the selection process raises the standard of any respected exhibition.

Another viewpoint is that of the art-quilt artists. To have their art recognized as a valid expression that is both fresh and challenging, the artists prepare fiber works that not only meet the exhibition criteria but will also stand out as a new artistic interpretation among other entries.

There are criteria that must be followed, but there are always openings available to the artist that may be utilized to find a new approach for using ideas and techniques within the media.

Enter the patron and the benefactor. These private individuals, organizations, and corporations secure the position of the exhibition by supporting it over the years so that, in addition to the artist's personal honor of having work selec ted for show, specific rewards are given to outstanding work within the already refined body of works.

And the fifth perspective is that of the audience for whom the show is created. Art is a form of communication, and it is the public that is finally given the opportunity to appreciate, evaluate, and verbally reward, or question, for the duration of the exhibition and the tour that follows.

And so, what do we look for in every art exhibition? Whether it is fine art or folk art, our responses can be the same. Does it amaze us? Does it please us, or even make us smile? Is it impressive for a variety of reasons? Is the idea risky? Are we surprised and challenged to re-think what we like or dislike? Does it communicate an idea?

In selecting my choices for Quilt National 2009, I looked for honesty of idea, artistic integrity, and trust. Did the work represent the individual artist who created it? Can a simple solution be as valid as a complex one? Did the artist use restraint in an effort to refine an idea?

For the days spent in the jurying process, I was rewarded by being part of an energetic art experience. Discovery happened over and over again. Now that the exhibition is about to begin a two-year existence, I hope that this show will inspire, teach, and continue to provide an enriching experience for all who see it.

*bio*Sue Benner

While pursuing a degree in molecular biology and a master's degree in biomedical illustration, Sue Benner created her vision of the microscopic universe in painted and quilted textile constructions. Her early work propelled her to become a studio artist in 1980, working primarily in the medium that later became known as the art quilt. The biological cell is a particular source of fascination for her. The shapes live in her mind and are the building blocks of her world and art. Here she sees a direct connection with the concept of quilt and the assembly of units. Sue is an innovator in her field, creating original, dyed and painted fabrics, which she combines with recycled textiles to form fields of structured pattern, vivid beauty, and riotous variation. Her artwork is in many private, corporate, and institutional collections. She also lectures and teaches workshops, nationally and internationally, in the fields of surface design, textile collage, fused-quilt construction, and artistic inspiration. Her work has been juried into Quilt National seven times. Living in Dallas, Texas, with her husband Craig Jett and their two sons, Sue works in her studio built in the backyard of their family home. However, a part of her heart resides still in her home state of Wisconsin.

*bio*Katie Pasquini Masopust

Katie Pasquini Masopust is an award-winning, self-taught fiber artist. She has traveled the United States and abroad, teaching contemporary quilt design. Her style has changed over the years, from creating traditional works, to mandalas, and later to dimensional quilts. She then moved on to landscapes, fracturing them and adding transparencies and color washes. Her most recent work is based on her acrylic paintings. She feels as if she has returned full circle to her beginning as a painter. Painting now with fabric, she teaches in a relaxed but energizing style, passing on her extensive knowledge of design and the art quilt to her students. Katie has authored eight books on art-quilt design and is a past president of the Studio Art Quilt Associates. She was awarded the Silver Star award at Houston in 2005.

*bio*Ned Wert

Ned Wert is a Professor Emeritus of Art from Indiana University of Pennsylvania. After retiring from teaching painting at the undergraduate and graduate levels for 18 years, he continued at IUP as director of the University Museum for eight years, curating exhibits focusing on the arts, and guiding exhibitions on local history, ethnic crafts, and archeological studies, among other subjects. As an exhibiting and award-winning, contemporary abstract painter, he has shown his work in solo and juried group shows for more than 40 years in the United States on the East Coast, Germany, France, Italy, and Switzerland. Recognized jurors who have chosen his work include Paterson Sims and Barbara Haskell, contemporary curators at New York's Whitney Museum of Art; Philip Pearlstein, painter and author; Ned Rifkin, contemporary-art curator at the Hirshhorn Museum in Washington, D.C.; Sam Gillian, painter; Gerald Norland, director of the Milwaukee Art Museum, and Madeline Gynsztein, curator at the Carnegie Museum of Art in Pittsburgh. His works are in museum, corporate, and private collections in 30 states and ten foreign countries. Ned has taught art-quilt design classes at the Quilt Surface Design Symposium; Nancy Crow's Barn in Baltimore, Ohio; the Allegre Retreat in Santa Fe, New Mexico; the Coupeville Art Center in Whidbey Island, Washington, and at numerous other venues, both in the United States and abroad. He has also curated several art-quilt exhibitions in Pennsylvania and Ohio.

Eileen Lauterborn
Graffiti
(detail)

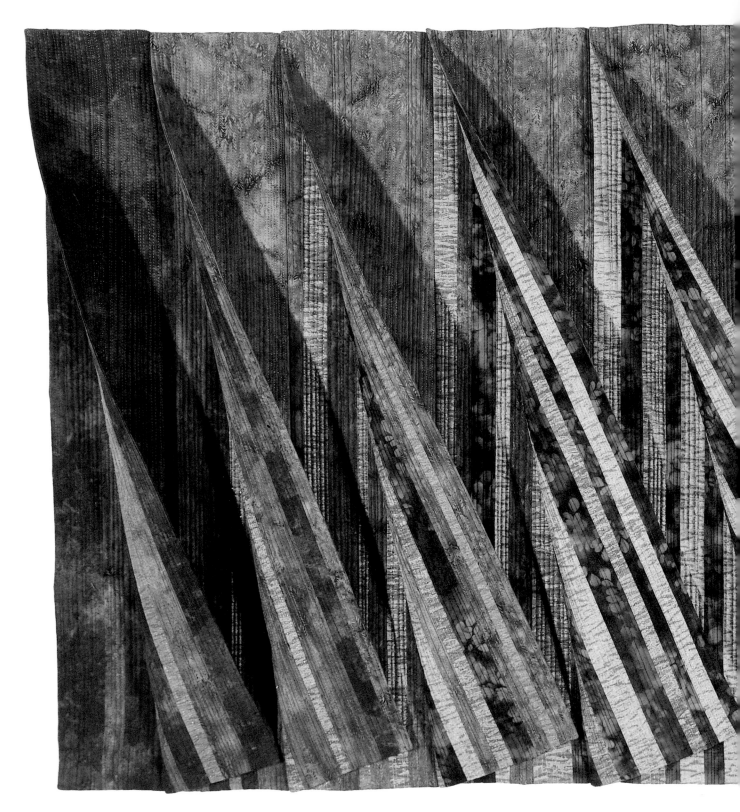

Anna Hergert
Moose Jaw, Saskatchewan, Canada

A recent move to lake property has heightened my senses and observational skills of natural phenomena. Experiencing a steamy hot midsummer day from early morning to sunset lets me appreciate the slightest breeze. Small waves gently lap at the lake shore, while the fractured reflection of the sun provides natural highlights.

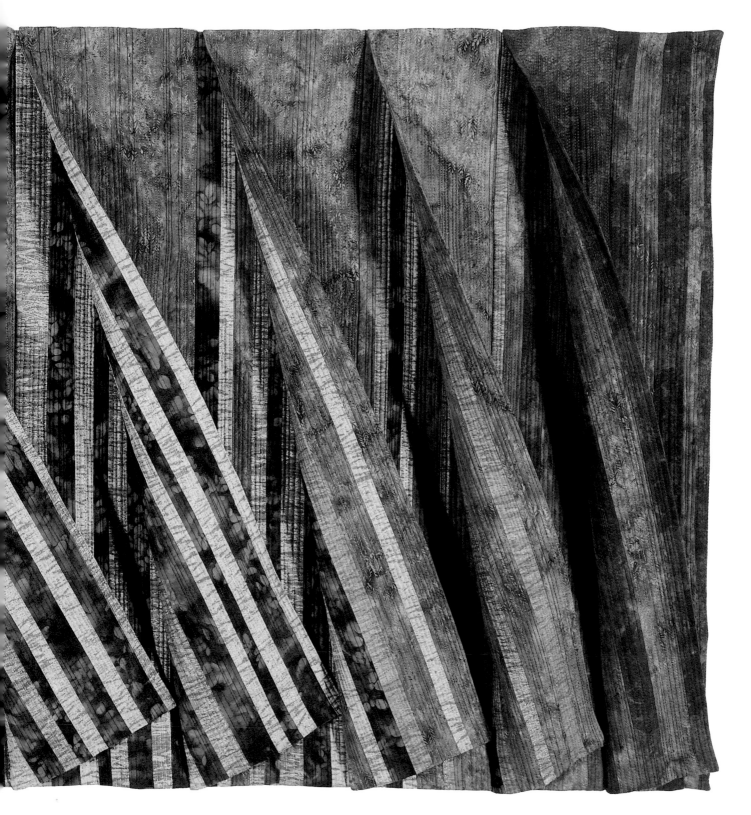

Summer Day at the Lake: Dawn to Dusk
2008

Cotton, metallic, rayon, and cotton thread, metal snaps; machine pieced and quilted, panels inserted for added dimension

74"W x 39"H (188 x 99 cm)

Barbara W. Watler
Hollywood, Florida

Visits to Ontario, Canada, reminded me of bare trees seldom seen since my move to south Florida 50 years ago. These trees are part of the landscape in the Still River region of southeastern Georgian Bay. Editing my photographs reveals organic abstractions that excite the eye and provide endless compositions that are far more spontaneous than my earlier, contrived designs. The stark blackness and intricate intersections are like an exquisite black lace fabric against a pale silk sky.

Ontario Quest Triptych
2008

Cotton muslin, cotton canvas; machine stitched

60"W x 59"H (152 x 150 cm)

Patricia M. Goffette
Edmonds, Washington

*This piece is about the balanced configura-
tion of lines and shapes. The lines create
the random external surface of the spatial
forms and the opposition of shapes. The
intrigue is in finding your own meaning
interlaced among these cross-wired inter-
sections, outlines, and shapes.*

Haywire
2008

Douppioni silk, cotton, cotton
batting, cotton and Greek
cotton thread; whole-cloth
machine quilted

41"W x 46"H (104 x 117 cm)

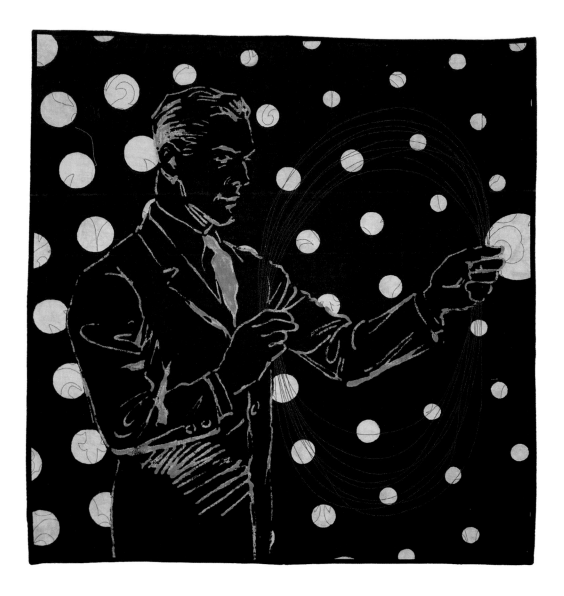

Bean Gilsdorf
Portland, Oregon

Shenanigan
2008

Cotton, dye, paint;
painted, machine
stitched and quilted

33"W x 35"H (84 x 89 cm)

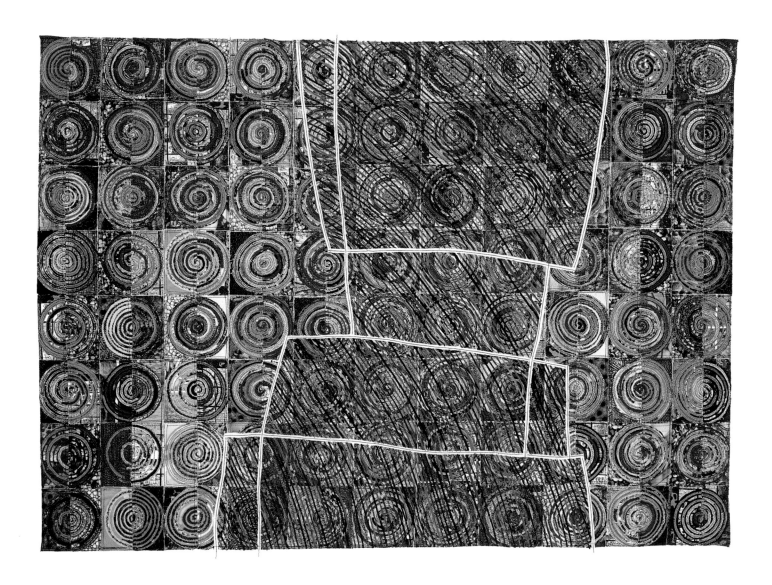

Jane Lloyd

Ballymena, County Antrim,
Northern Ireland

*This is part of a large series of work based
on the spiral. C.J. Pressma gave me a piece of
fabric he printed with pictures of stonework
from a trip to Indonesia. This was the starting
point. I needed more fabric, so I went to my
local beach and took pictures of stones. Then
more stones were added over all the spirals.
Hence, the Standing Stones.*

Standing Stones
2008

Cotton, canvas; layered,
fused, cut, machine
stitched

54"W x 39"H (137 x 99 cm)

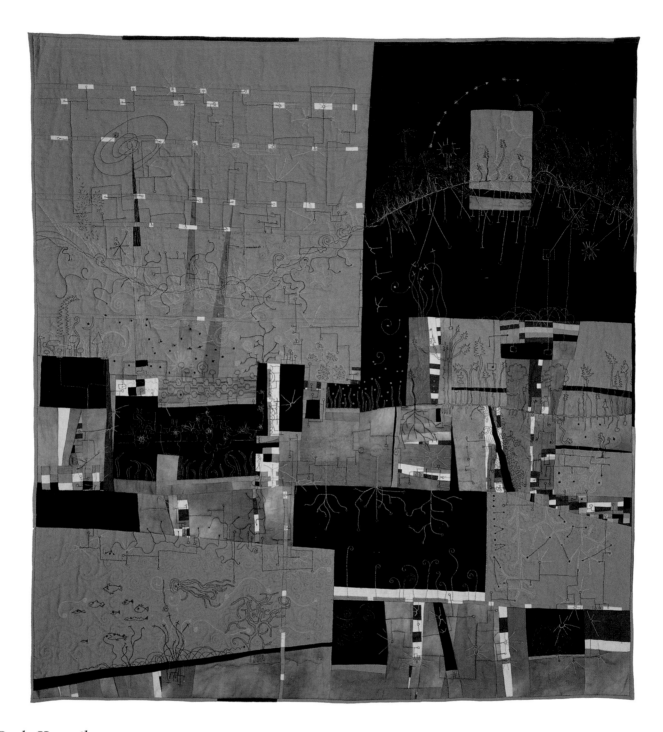

Paula Kovarik
Memphis, Tennessee

McCarthy Memorial Award

As a quilter, I strive to allow the unknown in. I believe there are many silent, invisible messages available to us at every moment in life. They can wrap us in anxiety, love, confusion, or hope. I work in a stream-of-consciousness manner—manipulating, reorganizing, and layering the fabric and thread in a way that mimics my thoughts. My quilts are a way of showing the invisible connections that we become aware of only upon reflection.

City
2008

Cotton; machine pieced, hand stitched, machine quilted

38"W x 42"H (97 x 107 cm)

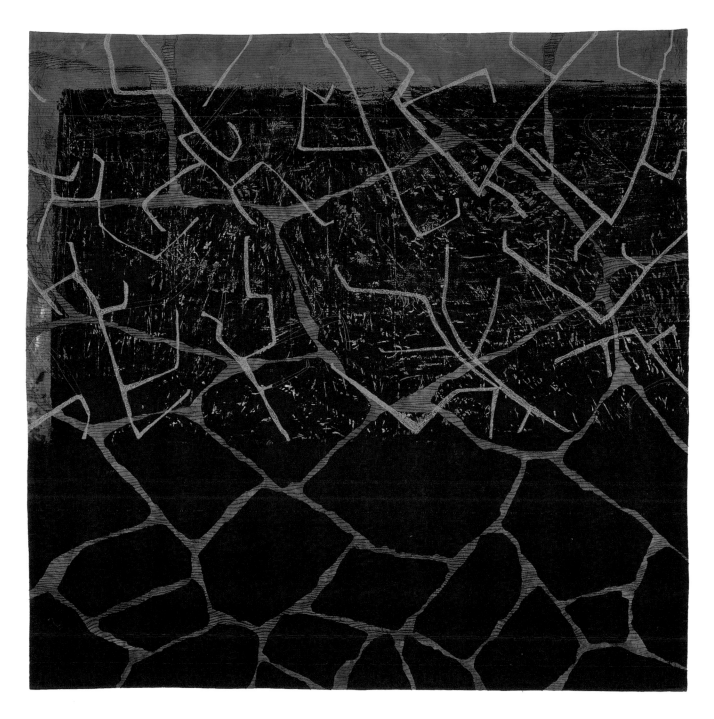

Ann Johnston
Lake Oswego, Oregon

In 2000 I dyed this cloth to hang—uncut and unstitched—and signed my name in ink on the lower left. In 2006 I cut it into pieces, interested in fitting shapes together and using changing sizes to create a directional flow with a sense of distance. In 2008 I quilted it. The lime green lines came last, contrasting in color, value, and emotion, breaking up the underlying pieces and sense of calm.

Diminishing
2008

Cotton sateen, dye; dye printed and painted, machine appliquéd and quilted

51"W x 51"H (130 x 130 cm)

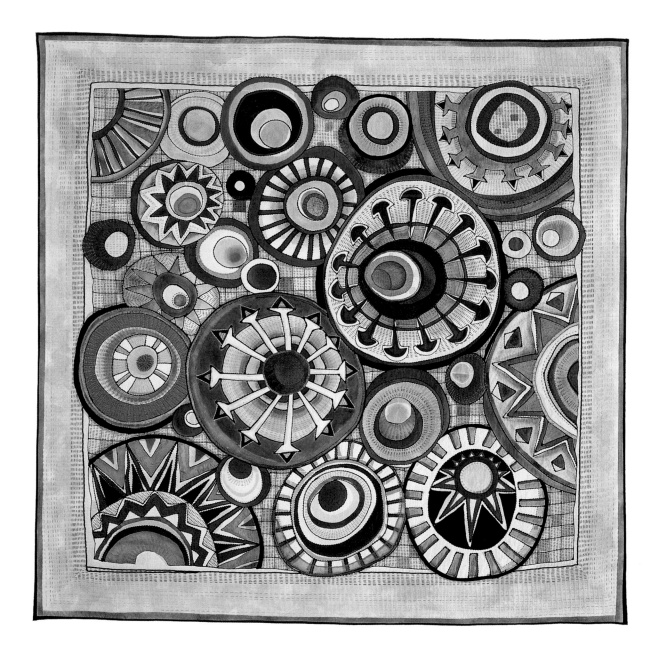

Marianne Burr
Coupeville, Washington

Sometimes it feels good to let loose. I'm an orderly person and usually create orderly designs, but it was time for a change. I let these circular forms take the lead and Spin Out is the result. I could get used to making this kind of fun.

Spin Out
2008

Silk, merino-wool felt, silk and cotton thread; resist painted, hand stitched and appliquéd

53"W x 53"H (135 x 135 cm)

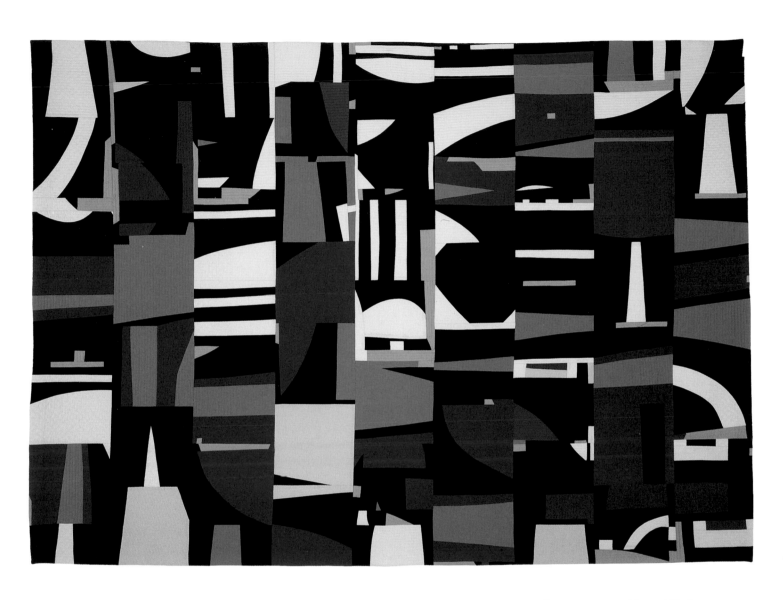

Pat Budge
Seattle, Washington

*My work is influenced by mid-century hard-edge
painters. About Herbin is the result of combining
separate hard-edge components into an integrated
panorama, reflecting a larger unconscious harmony
as seen so often in the world around us.*

Refraction #17: About Herbin
2008

Cotton; machine pieced and quilted

62"W x 45"H (157 x 114 cm)

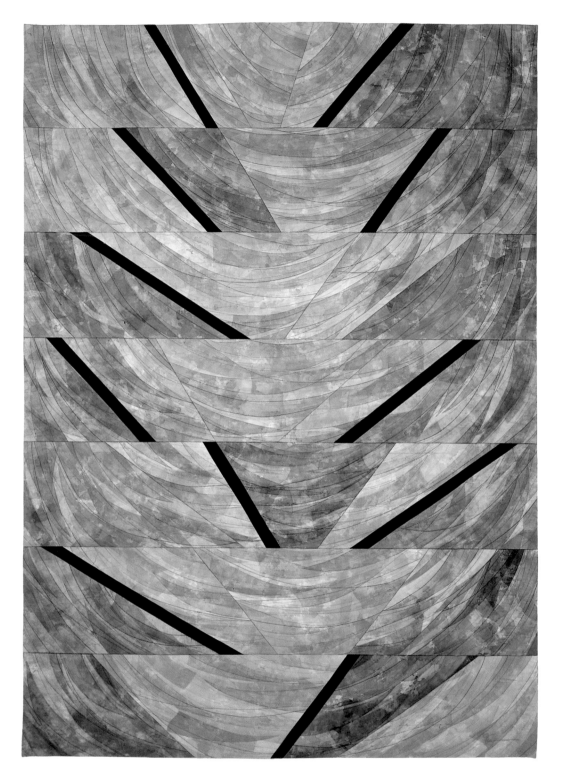

Nelda Warkentin
Anchorage, Alaska

This vision captures the swaying movement and grandeur of a great white pine with its strong limbs reaching towards the sky.

Meadow Pine
2008

Silk, linen, cotton, canvas; painted, machine quilted

49"W x 69"H (124 x 175 cm)

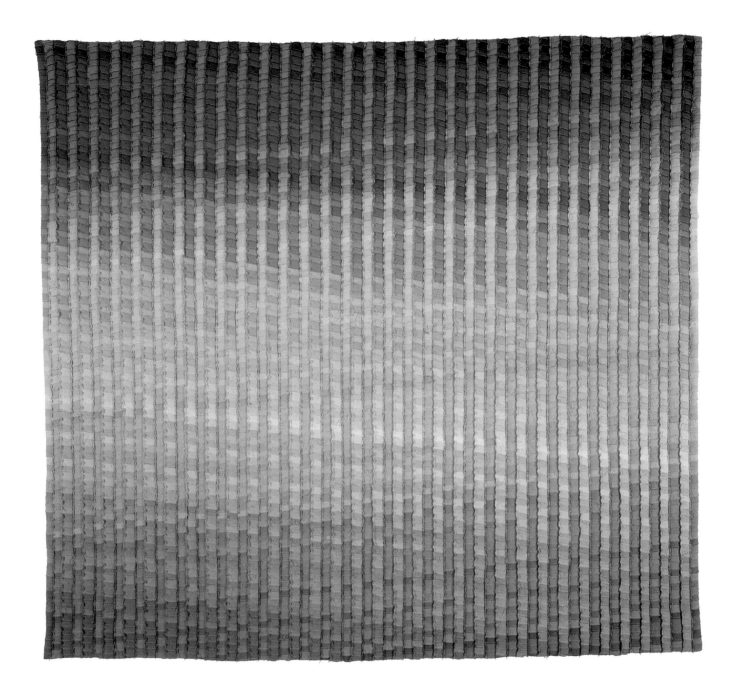

Inge Hueber
Cologne, Germany

For 30 years I have loved to go to Broadstairs, always "giving honor to the sea." The water stays the same, but changes all the time. It is beautiful to look at—any tide, any day. Broadstairs is a small, traditional, seaside town in England. Charles Dickens used to call it his "watering hole."

High Tide/Low Tide—Broadstairs, Kent 1
2007

Cotton, dye; machine pieced with visible seams, machine quilted

72"W x 66"H (183 x 168 cm)

27

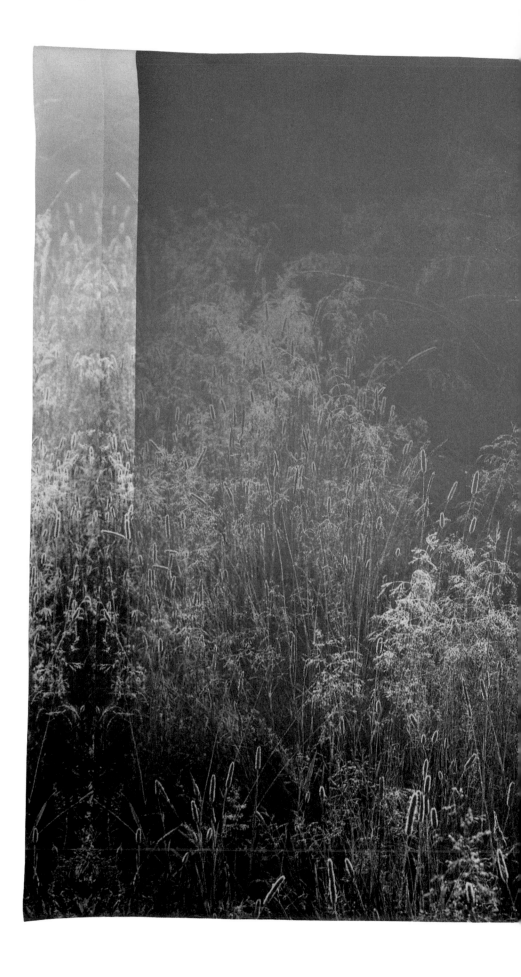

Britt Friedman
Oberlin, Ohio

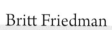

The Heartland Award

Grey Grasses IV
2008

Polyester/cotton, paint,
photographic images; painted,
composed

54"W x 37"H (137 x 94 cm)

*I try to use the medium in innovative
ways. My main source of inspiration
is the natural world. I think that I
have succeeded in combining all these
elements—photography, design,
paints—in my present work. I hope
the viewer will take pleasure in it.*

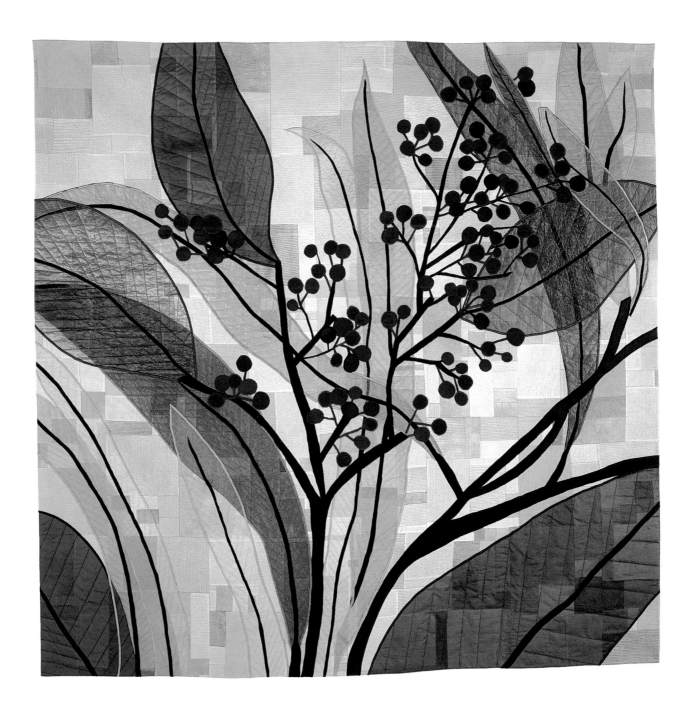

Carol Taylor
Pittsford, New York

Juicy, delectable spring berries pop in abundance amongst the delicate foliage. This quilt has a wispy, delicate quality due to the softly colored, pieced background and the sheer organza leaves, which create a see-through illusion. Each leaf and luscious berry is finished with satin stitching, helping to enrich the textures and layers.

Abundance
2008

Cotton sateen, silk organza, velvet, rayon thread, dye; pieced, direct appliquéd, free-motion quilted

63"W x 63"H (160 x 160 cm)

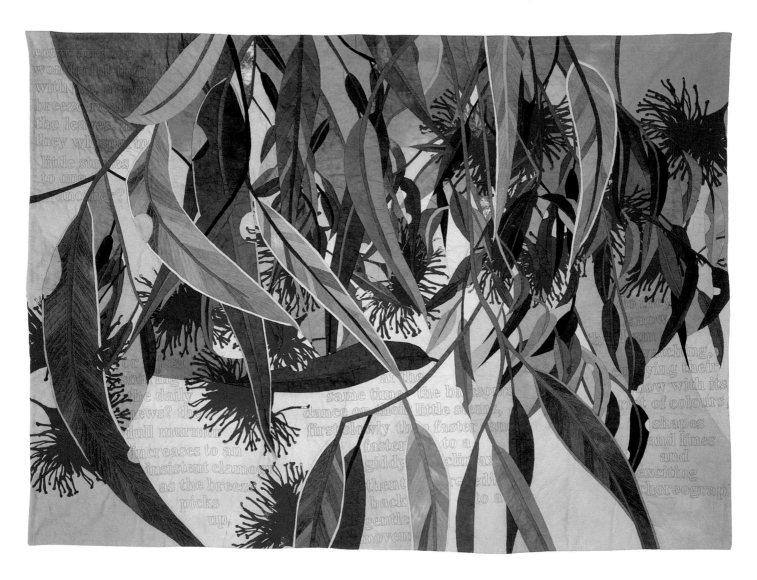

Ruth de Vos
Mount Nasura, Western Australia, Australia

Have you been to see Eucalyptus Spectacular?
Walking through my local neighborhood, I
pause and enjoy my front-row seat to this
dancing extravaganza, a celebration of the
awesome beauty of God's creation.

Eucalyptus Spectacular
2008

Cotton, dye, cotton wadding;
dyed, screen-printed, machine
pieced and quilted

60"W x 43"H (152 x 109 cm)

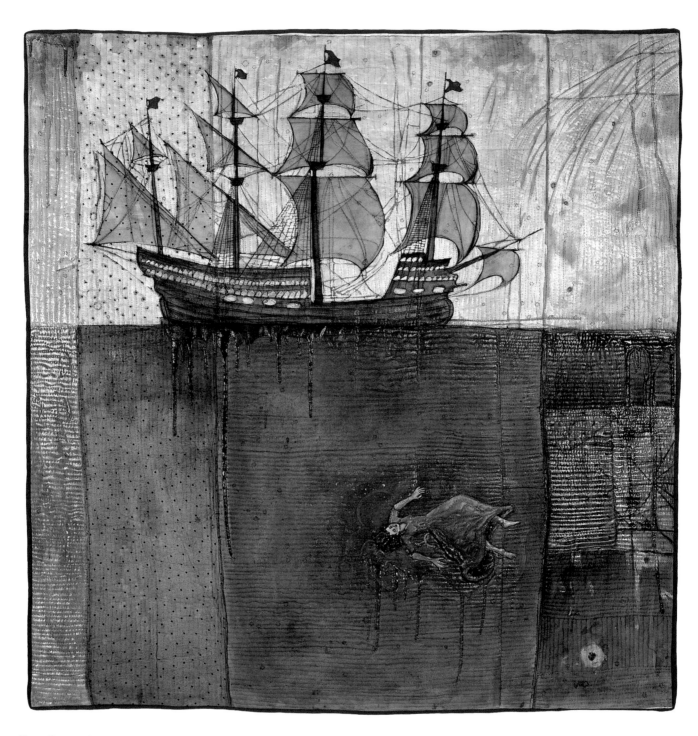

Jen Swearington
Asheville, North Carolina

Award of Excellence

I thrill in imagining and illustrating stories that have yet to be written. I hope you will bring your own tales to my drawings among the stitches.

The Sea Dream
2008

Bed sheets, rusted-silk binding, shellac, gesso, ink, charcoal, graphite, acrylic medium, dye; painted, machine pieced and quilted

44"W x 46"H (112 x 117 cm)

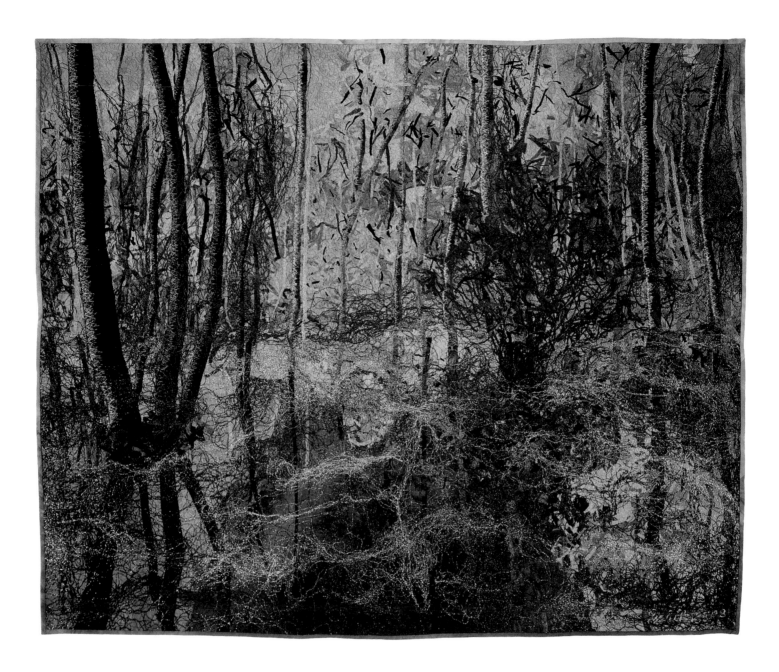

Noriko Endo
Narashino, Chiba, Japan

This piece is part of a recent series of work that deals with changing colors through seasons and reflections. The play of light reflects on the water.

Autumn Reflections
2008

Cotton, dye, tulle, luminescent fibers, yarn; machine quilted and embroidered

52"W x 44"H (132 x 112 cm)

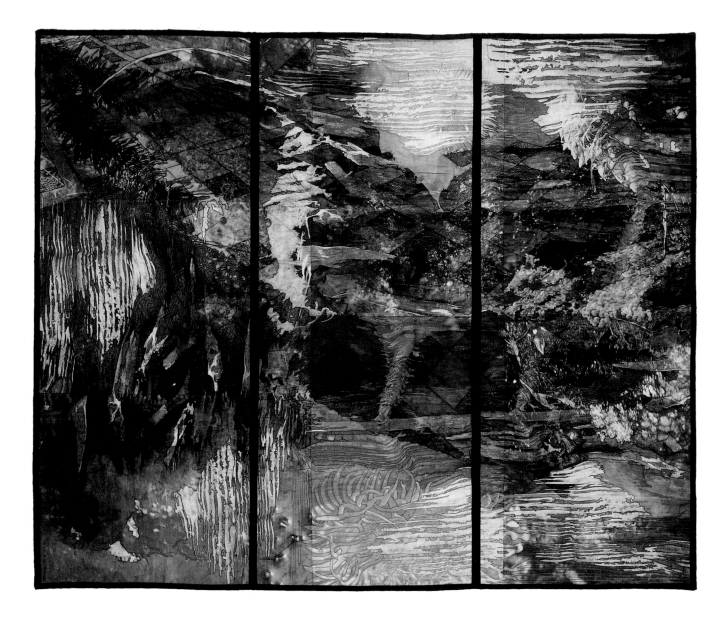

Robert S. Leathers
San Diego, California

Asilomar is part of an ongoing exploration of mankind's built environment intruding into nature. The seven double-exposure photos pieced into this work were taken at Asilomar Retreat in May 2008. The subject matter was tidal pools and driftwood. The grid is machine stitched.

Asilomar
2008

Cotton, wool, fabric paint; photographed (double exposure), inkjet transferred, machine pieced and stitched

42"W x 35"H (107 x 89 cm)

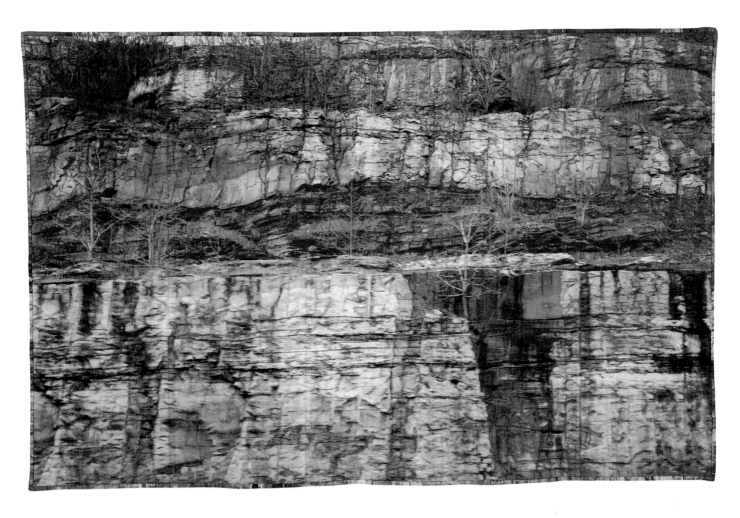

Patricia Mink
Johnson City, Tennessee

From an original photograph, taken through my car window while driving through the mountains.

Appalachian Landscape II
2008

Cotton muslin, cotton batting, linen; inkjet printed, machine stitched

58"W x 38"H (147 x 97 cm)

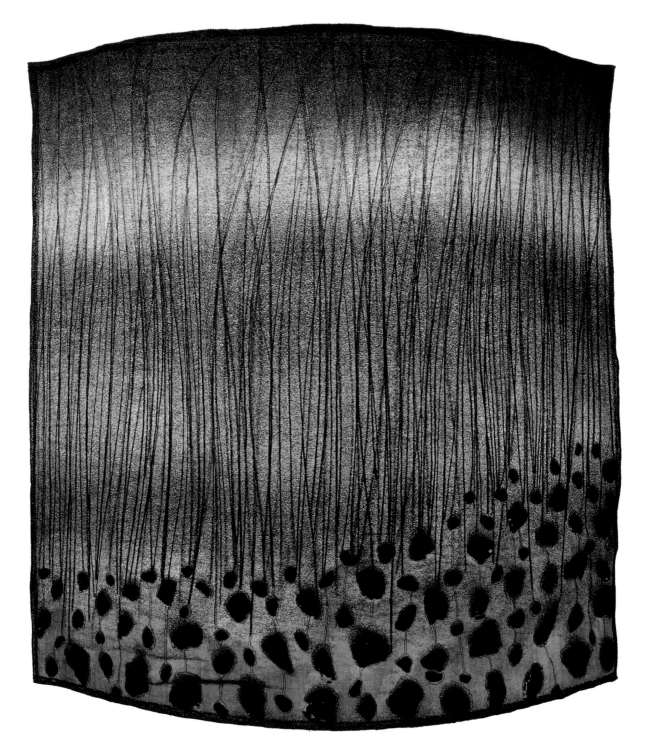

Regina V. Benson
Golden, Colorado

The early morning light bounces off the lake and through the tall reeds. Those dewy, lakeside mornings rustle with waking deer and nesting birds—promising another calm day. I hope this art quilt evokes that early morning panorama, with soft light dancing off the water's surface, beckoning to those quiet times.

Lakeside Morning
2008

Cotton, felt, paint, polyester thread; dyed, discharged, resisted with rocks and reeds, watercolor-pigment painted, bare-needle stitched

43"W x 41"H x 9"D (104 x 109 x 23 cm)

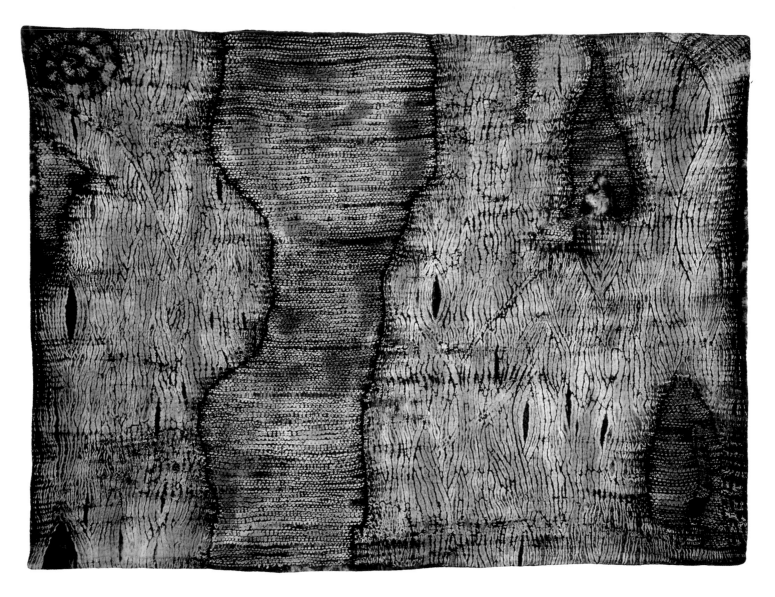

Sue Cavanaugh
Columbus, Ohio

Lynn Goodwin Borgman Award
for Surface Design

*This work explores surfaces and what lies beneath
the surface. What was once there—now gone—that
makes the surface what it is today? I'm especially
drawn to old stucco buildings—with partially
eroded surfaces that suggest the passage of time. I'm
drawn to openings—in vessels and the bark of a
birch, black holes in the universe, and the rabbit hole
that beckoned Alice.*

Ori-Kume #1
2008

Cotton sateen, dye;
shibori-stitch resisted,
hand quilted

39"W x 29"H (99 x 74 cm)

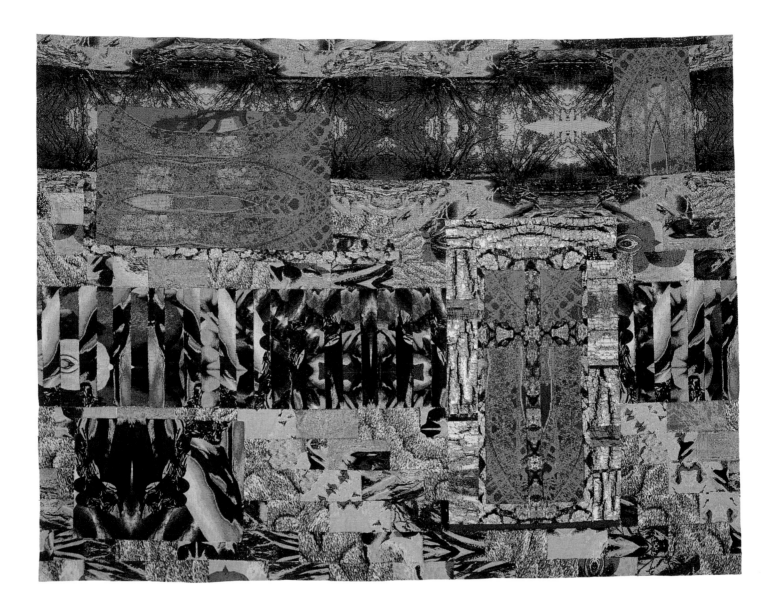

David Brackett

Lawrence, Kansas

Each day we make hundreds of choices, most of which seem insignificant. We are also confronted daily with unexpected events. My work reflects the order we seek in our lives while living in a world filled with chance and unpredictability.

Good Neighbors
2007

Cotton; jacquard woven, pieced, machine stitched

67"W x 52"H (170 x 132 cm)

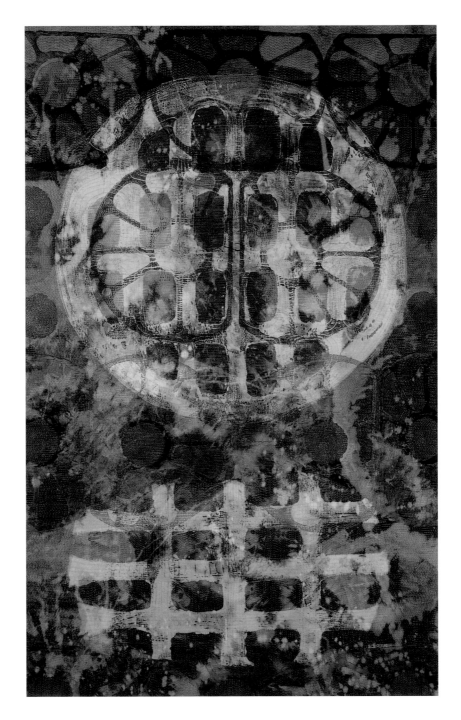

Bob Adams
Lafayette, Indiana

Several events led me to this series—one being the collapse of the I-35W bridge into the Mississippi. We all take for granted that when it rains our drainage system whisks away the water. Over time the system has become antiquated and in disrepair. This is what has inspired me to use manhole covers and storm grates as a beginning to this series. I began working sketches and moved on to discharging and printing with polystyrene foam. This is just the beginning.

Infrastructure No. 32
2008

Cotton; whole-cloth machine embroidered

40"W x 62"H (102 x 157 cm)

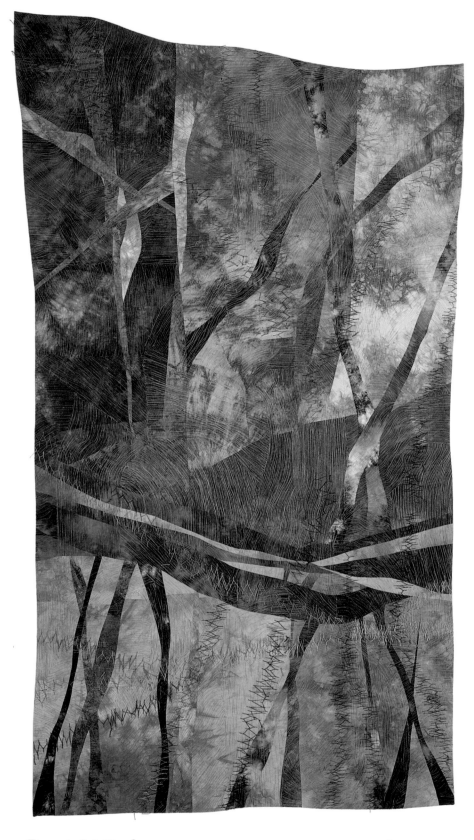

Bonnie M. Bucknam
Vancouver, Washington

*I try to fill my space in an interesting
or beautiful way, while leaving the
mark of my imperfect hand.*

Reflection
2008

Cotton, dye; machine pieced
and quilted, hand stitched

40"W x 72"H (102 x 183 cm)

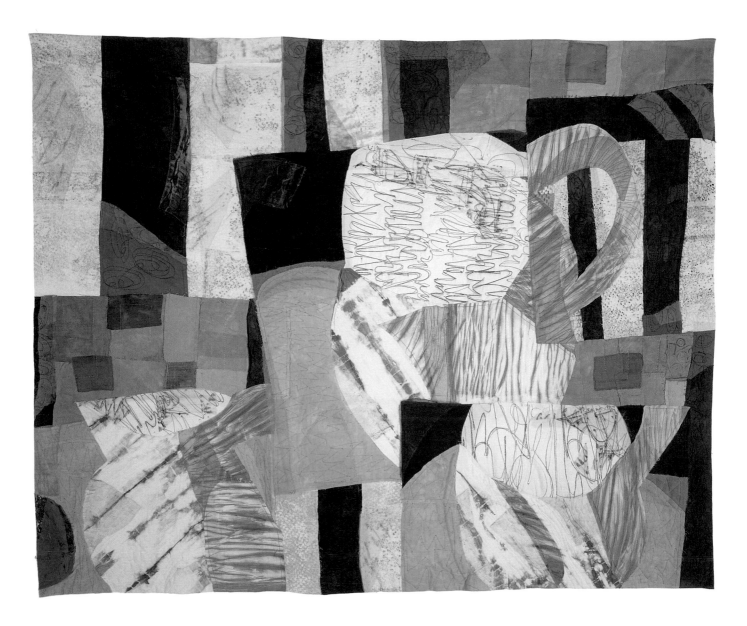

Dominie Nash
Bethesda, Maryland

The objects with which we surround ourselves range from the mundane to the exquisite. Wherever on the continuum they fall, they often become invisible. The challenge is to look at them with an eye for their contribution to an interesting composition. Seemingly insignificant objects may turn out to have the most interesting shapes or patterns. Searching for these becomes an important part of the design process, while putting one back in touch with one's surroundings.

Stills From a Life 35
2008

Cotton, silk organza cotton batting; machine appliquéd and quilted

59"W x 48"H (150 x 122 cm)

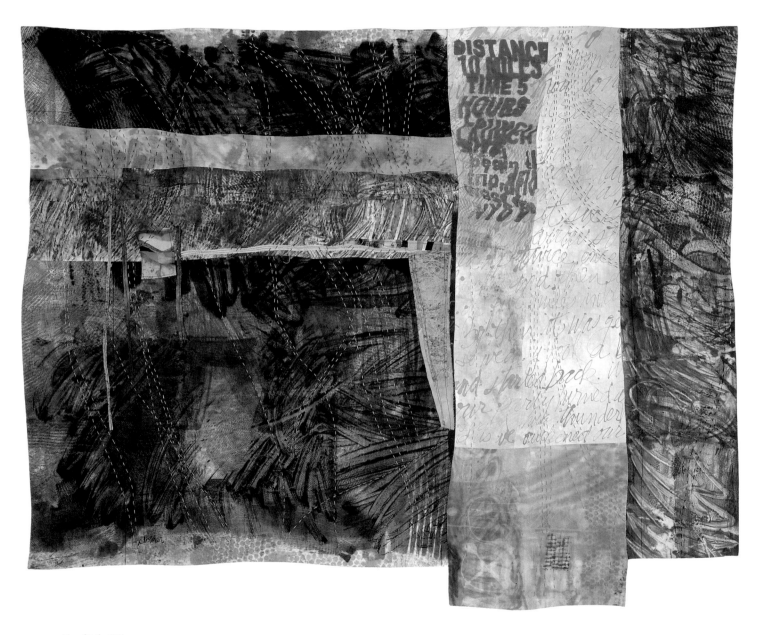

Judith Plotner
Gloversville, New York

This piece was created after a seven-mile kayak trip through winding marshes, streams, and flows, over six beaver dams, and through two lakes. It was stunningly beautiful. We started on a clear blue day and ended in a huge but quick storm with very high winds. We each got dumped once. Using monoprinted dye, test, and stitching, I have tried to convey the experience and mood of this trip.

Notes on a Stream
2008

Cotton, silk, dye; pieced, appliquéd, fused, screen-printed, dye monoprinted, machine and hand quilted

54"W x 46"H (137 x 117 cm)

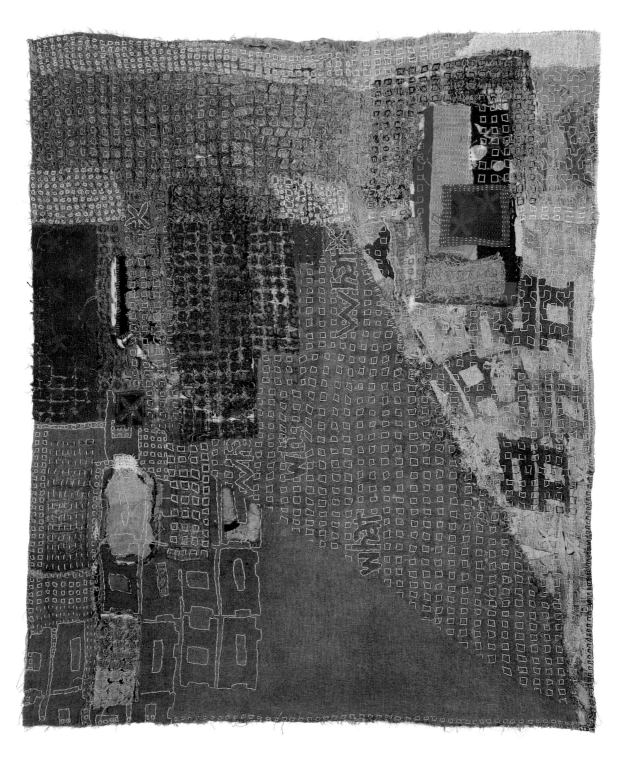

Judy Rush
Bexley, Ohio

Juror's Award of Merit

Silence is made up of many layers of fabric with separate but related compositions on each piece. After I hand stitch the layers together, I begin to cut into them. As I work toward revealing different parts of the layers, I discover that they are a lot like my own layers. It is difficult to cut into some parts, so I leave them be. I guess they are not yet ready to be revealed.

Silence
2008

Cotton, silk, linen, cotton embroidery floss; hand stitched, cut, mended

33"W x 40"H (84 x 102 cm)

Margery Goodall

Mount Lawley, Western Australia, Australia

Frail continent, quartet of conundrums:
Powdered land, slicks of salt;
Red rocks cracked and baking; powder softly silted.
Hot air moving, lost leaves crushed to whispers;
Salt lines drawn, as the wind sighs;
Wild fire! Life turns to ash;
The air is quiet; it waits.
Life begins… the circle turns, and turns, again.

Earth Suite: Saltland, Pindan,
Dune, Fire Ash (a quartet)
2007

Cotton, silk, rayon, cotton blends,
dye, textile ink, wool-blend batting;
machine stitched

64"W x 64"H (163 x 163 cm)

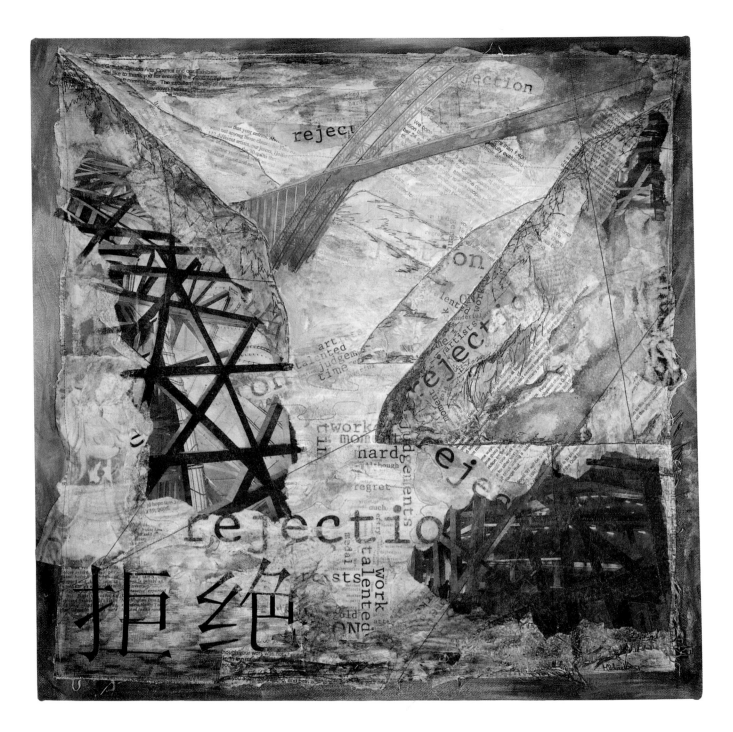

Maya Schonenberger
Miami, Florida

Reflecting on the elaborate and artful phrasing of my various rejection letters (and there are quite a few), I decided to use them in my new artwork. After a "call for rejection letters" among my artist friends, I started the project. China, the Olympics, and especially impressions of the Yangtze River provided the background for my work and should be a reminder that rejection is the other side of winning.

Rejections
2008

Cotton, blends, paper, print material; print and photo transferred, glued, appliquéd, machine pieced and quilted

20"W x 20"H (51 x 51 cm)

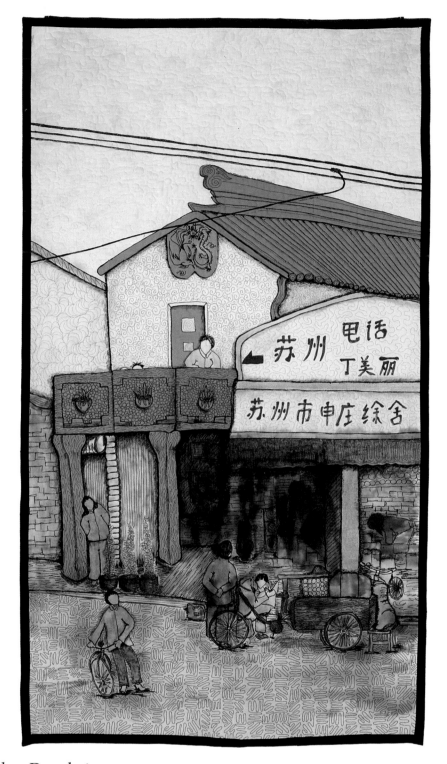

Mathea Daunheimer
Thomaston, Maine

Suzhou Street Scene *is another quilt in a series that com-
memorates my time in the People's Republic of China. I have
also called this piece* Suzhou Electric & Telephone, *as
that is what the signs indicate. The signs on the quilt do say*
Suzhou Electric & Telephone; *however, one of the lines is my
name. There was a great noodle shop in this space of shops,
and I met some wonderful people while consuming noodles.*

Suzhou Street Scene
2008

Cotton, ink, bamboo batting; ink
painted, free-motion quilted

23"W x 40"H (58 x 102 cm)

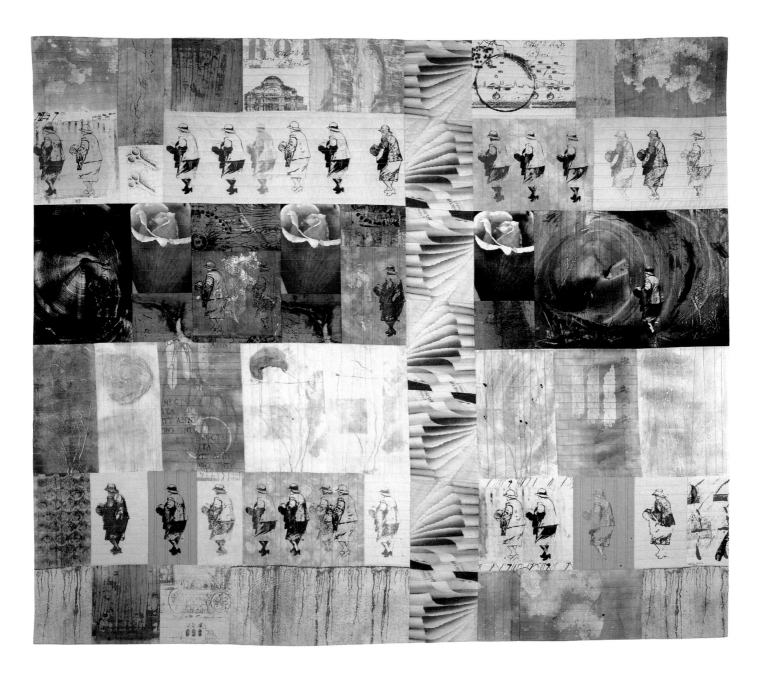

Linda Colsh
Everberg, Belgium

Act 3: a third piece about mystery, beauty, and the complexities of growing older.

Twisting the Plot
2008

Cotton, linen, dye, paint, computer images and screens; dyed, painted, printed, machine pieced and quilted

79"W x 68"H (201 x 173 cm)

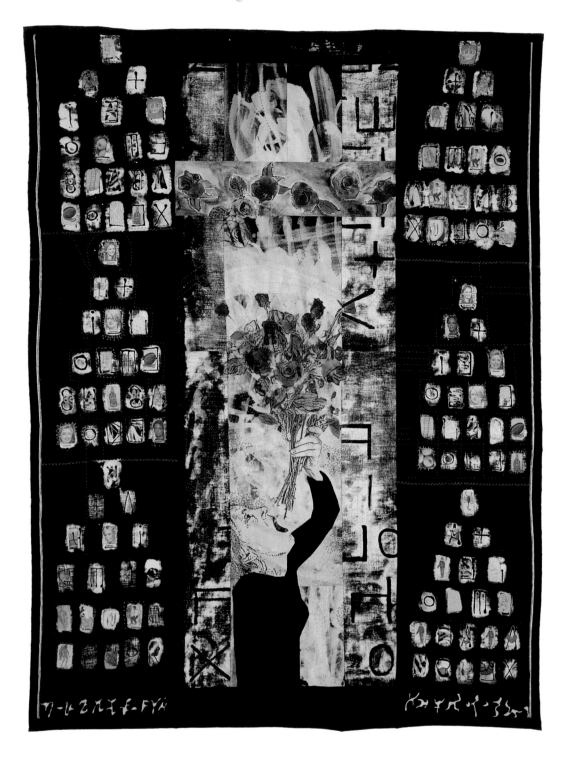

Susan L. Krueger
Bowling Green, Ohio

Cathy Rasmussen Emerging
Artist Memorial Award

This piece is about falling for various societal myths regarding Power, Fame, Beauty, Luck, and Money—the things we wish for. Notice the tiny images from Mexican lottery cards, women celebrities from the entertainment section, and fruit from seed catalogues. I could get all "feministy" on you and talk about the pressures to undermine women psychologically and politically but, suffice it to say, swallowing roses involves lots of physical and emotional training.

Swallowing Roses
2007

Cotton, fabric paint; batiked, discharged, image transferred, appliquéd, embroidered, hand and machine quilted

31"W x 41"H (79 x 104 cm)

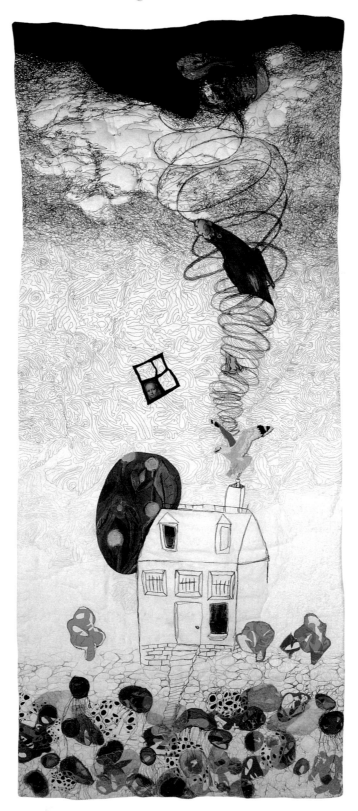

Leisa Rich
Atlanta, Georgia

No matter how bright and sunny our outlook, no matter how intensely we desire a life lived "glass half full," shifts and changes are givens. Sometimes life seems built upon quicksand—with happy moments that are readily overtaken by the next tornado.

My House Is Built on Sand
2007

Cotton, wool blends, paint, dye, whole cloth; fused, machine appliquéd, digitally transferred, painted, machine quilted

35"W x 81"H (89 x 206 cm)

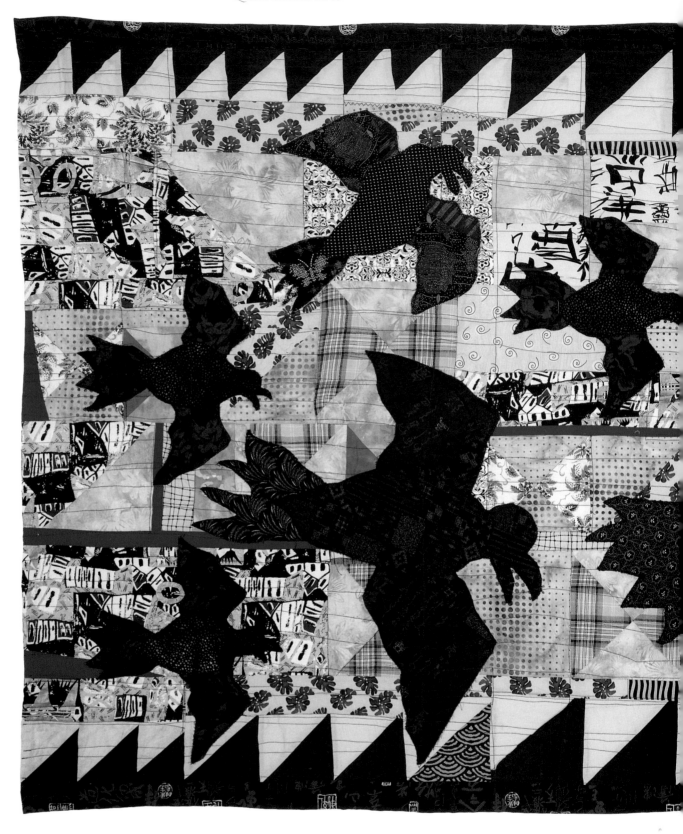

Ginny Smith
Arlington, Virginia

Birds are part of the natural world. They hop, walk, swim, and fly: flying from one branch to another, flying in small groups, flying as huge flocks, wheeling in concert above us or as frantic mobs, fleeing—sightless, directionless, or in response to some innate compulsion.

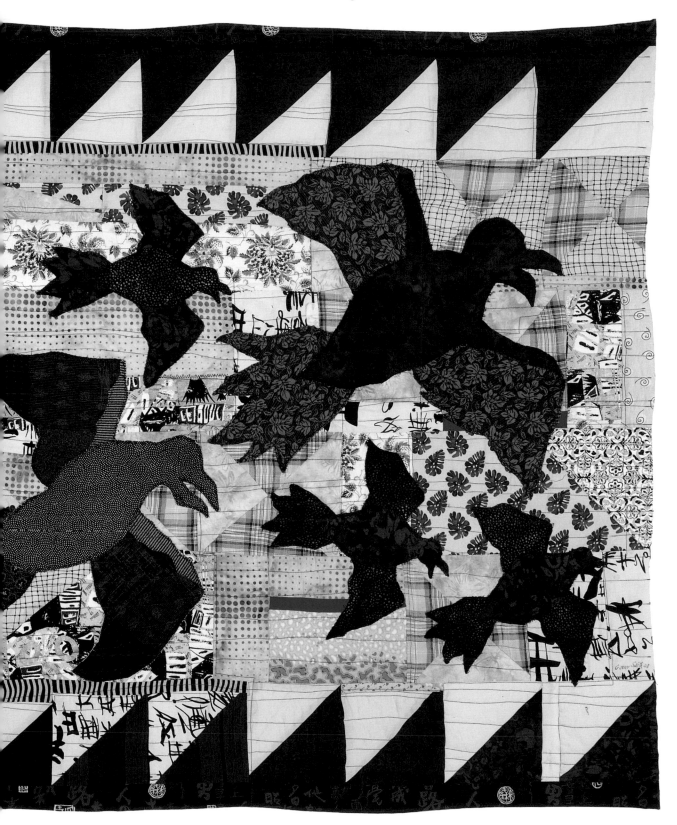

Eastbound

2008

Cotton, dye; raw-edge machine appliquéd,
machine pieced

75"W x 44"H (191 x 112 cm)

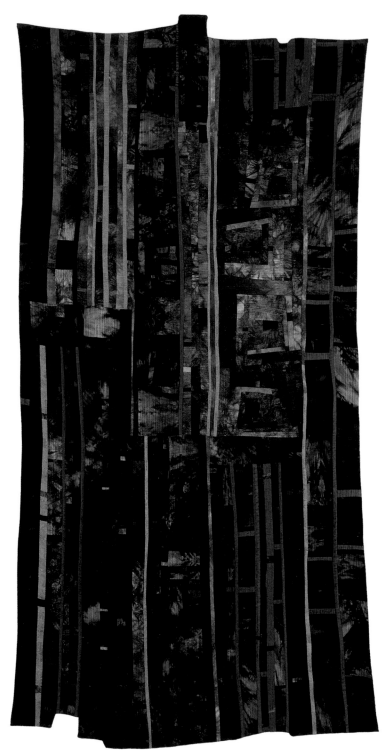

Beth Carney
Yonkers, New York

As my series of Structured Chaos *progressed, I became intrigued by using windows as if they were lenses through which I view the world. Playing with this concept of looking out or looking in, I discovered that windows appear in an endless series of windows within windows within windows. This piece has become a result of my reflections on how I look at the world—constantly looking and thinking about the endless possibilities and choices set before me.*

Structured Chaos 25
2008

Cotton, silk, bamboo batting, dye, cotton and metallic thread; machine pieced, appliquéd and quilted

35"W x 75"H (89 x 191 cm)

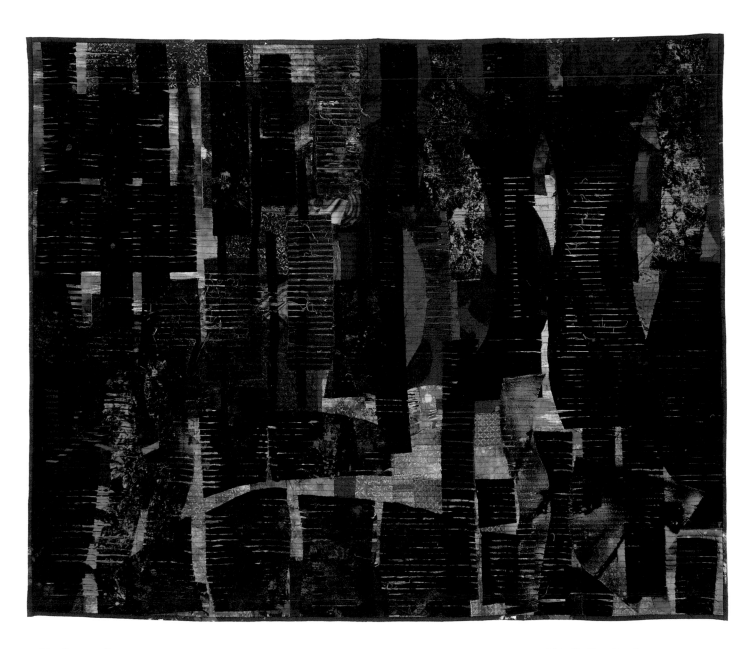

Shulamit Liss
Yokneam, Moshava, Israel

Standing by the window in my son's apartment on the top of the Carmel Mountain in the city of Haifa, the beautiful night views of Haifa Bay open up in front of me. The lights of the city blend with the lights of the ships in the bay and merge into the lights of the refineries. Streets and buildings, land and water, urban areas and industries, dark and light—the wonderful blending led me to this artwork.

Haifa Bay Lights
2007

Cotton, dye, bleach; printed, painted, collaged, reverse machine-appliquéd

59"W x 50"H (150 x 127 cm)

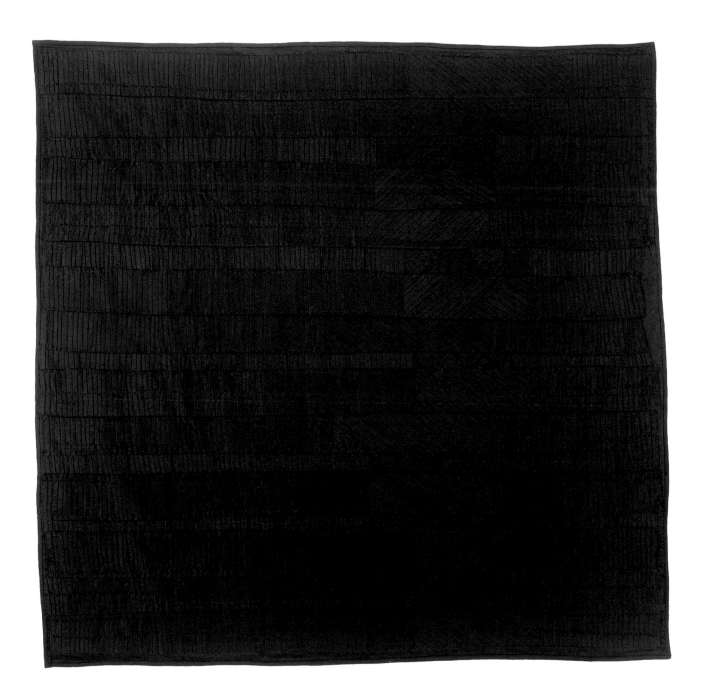

Gabriella D'Italia

Newburgh, Maine

*Quilts embody ideas and have functional purpose in a domestic context.
Through manipulations of fabric and stitching, I explore the intimacy between
manufactured objects and daily living. The idea of finery emphasizes both the
created nature and elevated status of this quilt. Its homogeneous, incremental
piecing refers to elemental concerns, both material and philosophical, or
relationships, boundaries, and scale, all framed in the context of home.*

Black Finery

2008

Cotton sateen, cotton batting;
machine pieced, appliquéd,
embroidered, hand quilted

64"W x 64"H (163 x 163 cm)

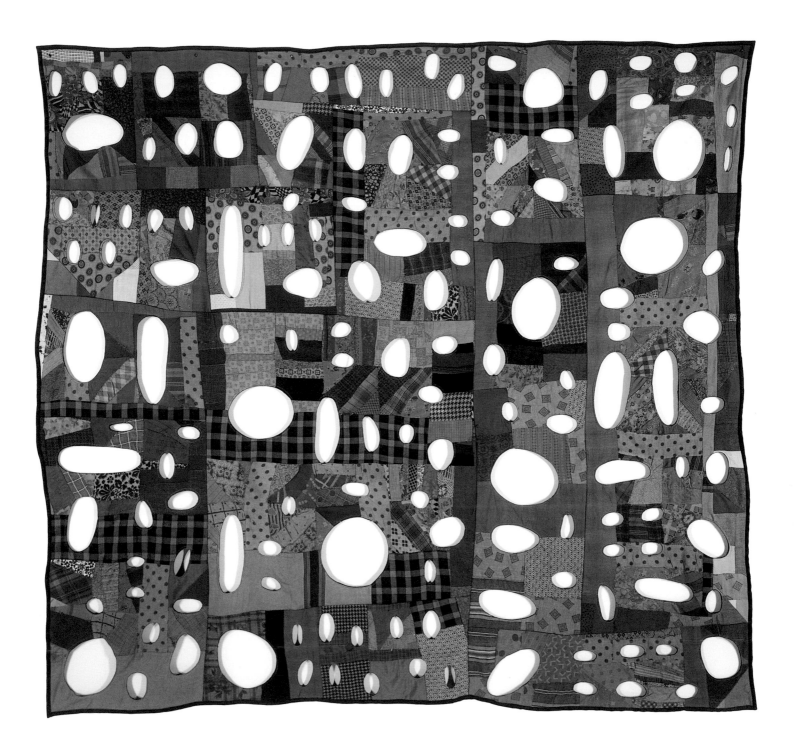

Aaron McIntosh
Richmond, Virginia

With this quilt, pieced from found vintage quilt tops, I have challenged our common notions of quilts as protective, comforting bedding. The sullied grey reminds us that all stages of life happen beneath quilts, even the unpleasant ones such as birth, sickness, and death. An all-over perforation of oval holes strips the quilt of its function and acts as a portal through which to ponder the stories of those who previously lay under the quilt. These perforations also represent holes and layers in our memories.

Communicating with the Past
2008

Vintage cloth, cotton, blends, felt, dye; pieced, reverse appliquéd, machine stitched

78"W x 71"H (198 x 180 cm)

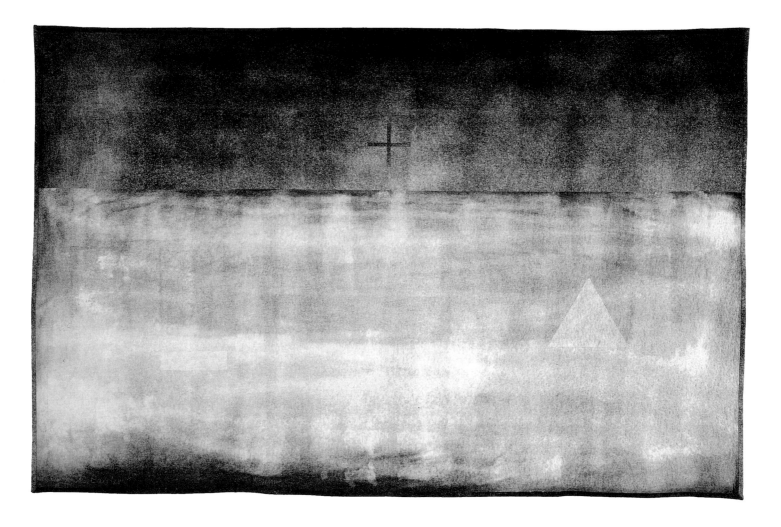

Clare Plug
Maraenui, Napier, New Zealand

Antarctica's floating Ross Ice Shelf is the size of Texas and, on average, 1,000 feet thick. It was called "The Great Ice Barrier" by the early explorers who toiled across it for weeks on their quests south toward the South Pole. Out on this vast, bright, featureless expanse of drifting snow and driving winds, one's eyes might play tricks.

I gratefully acknowledge the support of Antarctica NZ and Creative NZ.

Antarctica Series: Out on the Barrier
2008

Cotton, non-woven polyester, dye; discharge dyed, machine pieced, appliquéd and quilted

72"W x 47"H (183 x 119 cm)

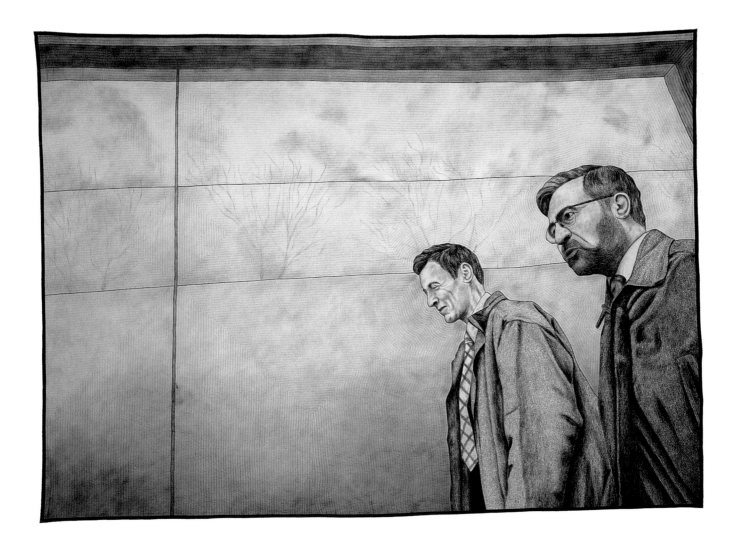

Inge Mardal and Steen Hougs
Chantilly, France

Hinting at a downtown setting, this composition with two gentlemen illustrates that a well-focused discussion can compete with the surrounding distractions of a busy place.

Walking Conversation
2008

Cotton, thread, fabric paint; whole cloth, hand painted, free-hand quilted

65"W x 48"H (122 x 165 cm)

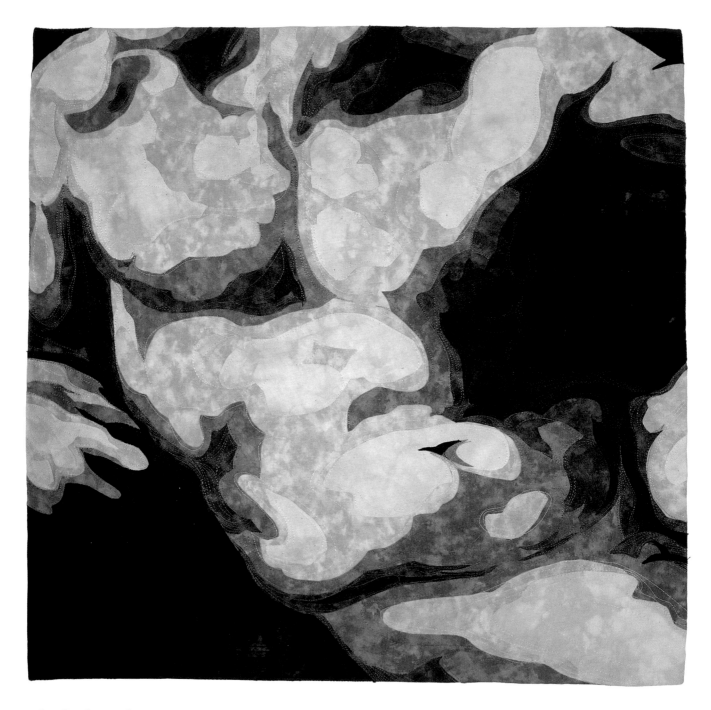

Elizabeth Poole

Garrison, New York

I'm an engineer: I construct things. I believe in the power of construction and collage. I believe that message can be delivered through the juxtaposition of layer on layer. Neither Michelangelo's fresco nor Mapplethorpe's photography can be duplicated in this medium, but they can be touched and transformed.

MappleAngelo
2006

Cotton, dye, rayon thread; raw-edge appliquéd, free-motion machine stitched

24"W x 24"H (61 x 61 cm)

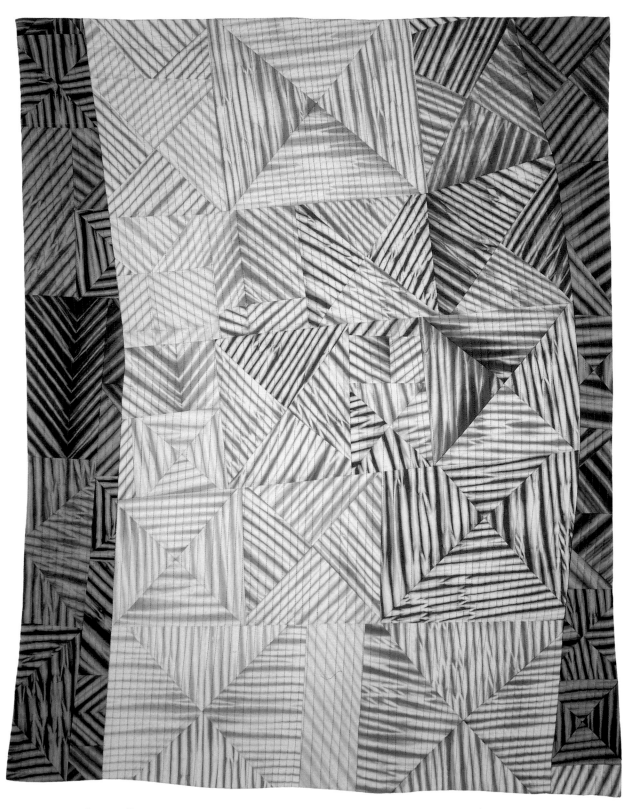

Mary Lou Alexander
Hubbard, Ohio

A glacier is just a chunk of ice—cold, inanimate, remote. Who
would guess that all of our lives and those of the plants and
animals of the earth are so dependent upon its existence?

Glacier
2008

Cotton; shibori dyed, machine
pieced and quilted

38"W x 48"H (97 x 122 cm)

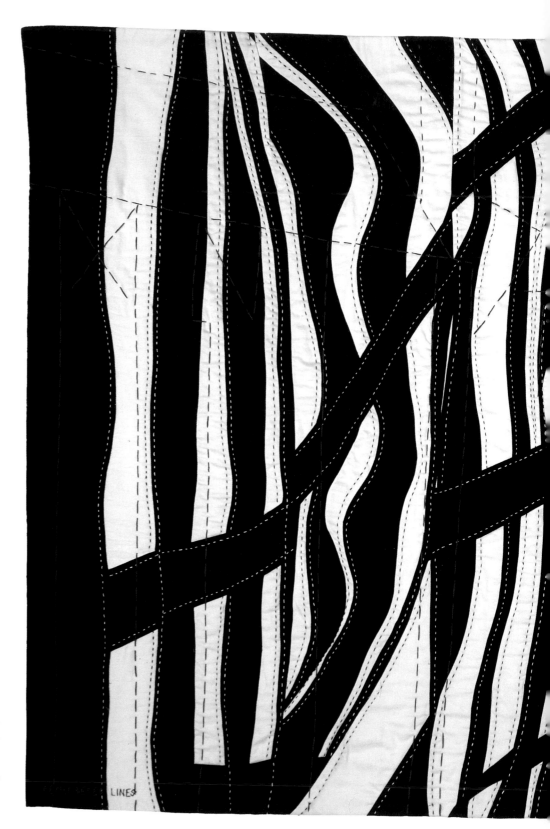

Elizabeth Barton
Athens, Georgia

Remembered Lines
2007

Cotton, dye; dyed, pieced,
hand and machine quilted

69"W x 41"H (175 x 107 cm)

This quilt is the twelfth in a black-and-white series based on medieval buildings in England. I have always loved their timbered exoskeletons! The effect of time, nature, and memory on architecture has been a recurring theme for me since I began making quilts. I want to be less obvious, eschew kitsch, and focus on the abstracted essence of the inspiration. Eat Art and Live!

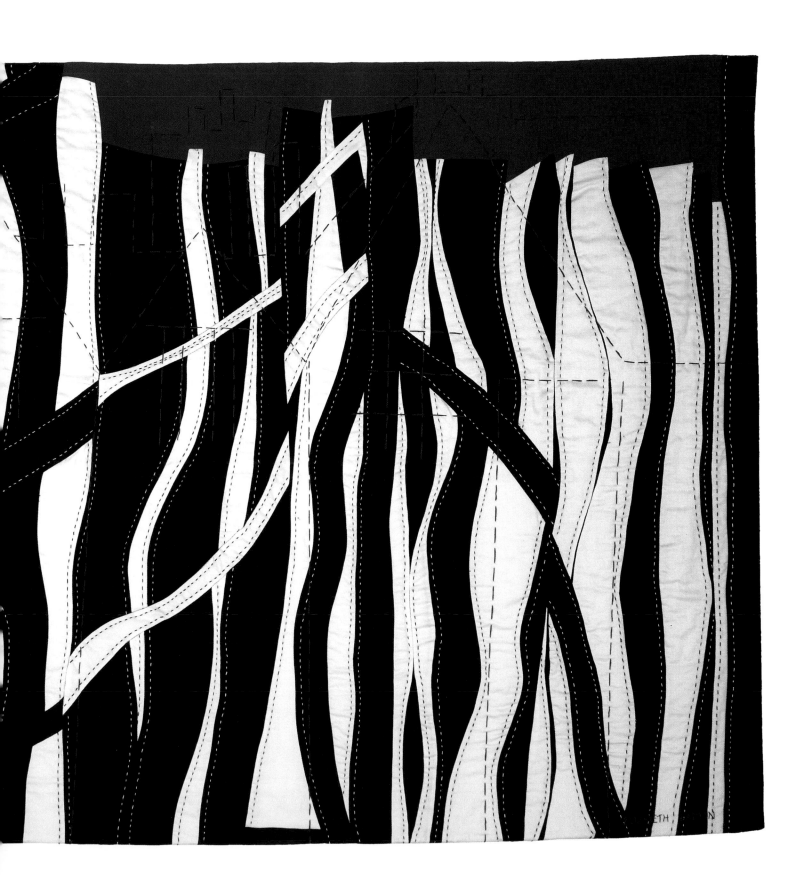

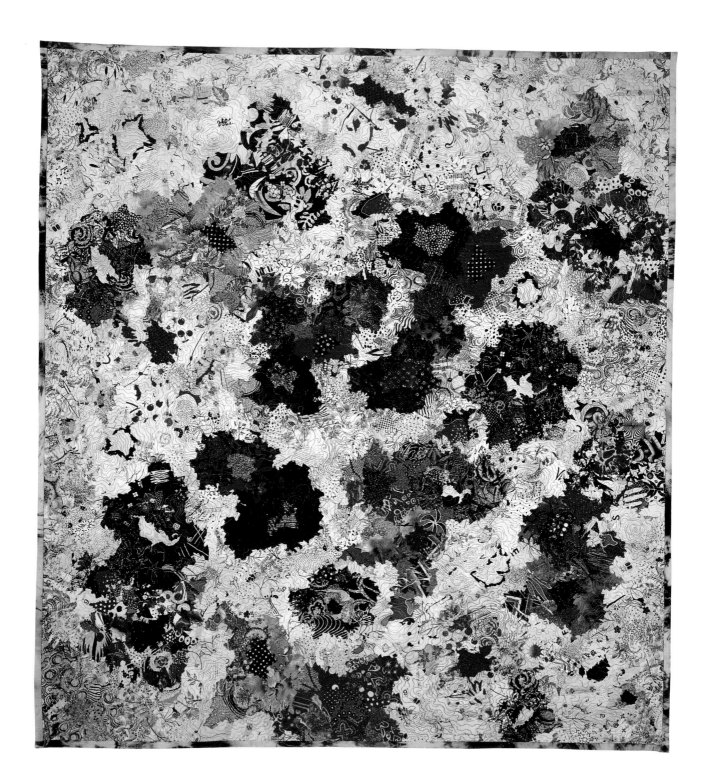

Maya Chaimovich
Ramat-Gan, Israel

*The art quilt is a language for me to tell my stories and feelings. I
try to express my happy, strange, and sometimes lonely moments.*

Together and Apart
2008

Cotton, silk, wool, velvet, lace,
synthetic fabrics from old
clothes, fusible interfacing,
metallic thread; pieced, machine
free-motion quilted

50"W x 55"H (127 x 140 cm)

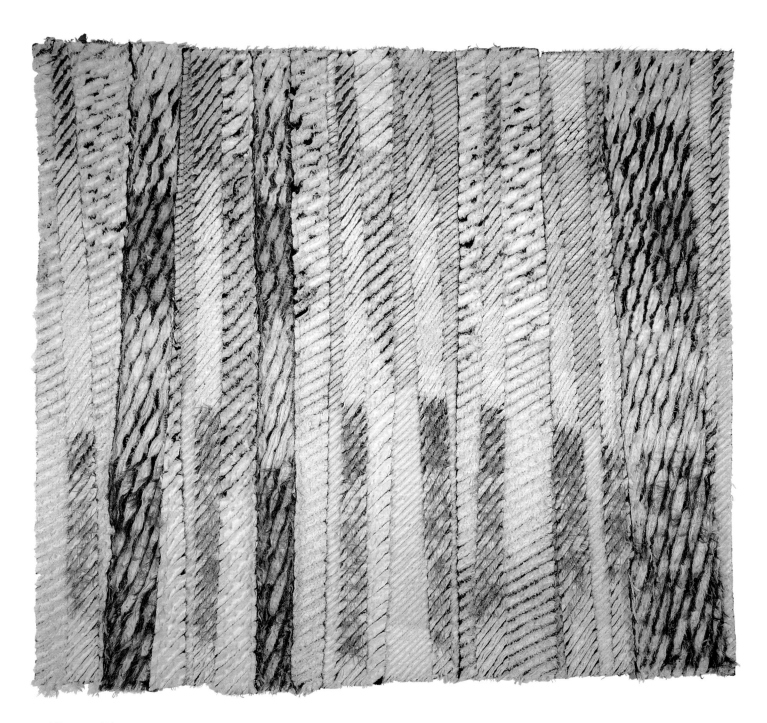

Karina Thompson
Birmingham, West Midlands, United Kingdom

This piece was inspired by walks through the snow-covered pine and birch forests of the Cairngorm Mountains in Scotland. I hope to capture the silence and mystery of a heavy snowfall in woodland, and the tranquility and comfort I get from being in such a beautiful place. The piece is made by "slashing," a robust machine-stitch technique that allows complex surfaces and color mixes to be created.

Cold Comfort
2008

Cotton, polyester, silk, metallic yarn, Swarovski crystals; machine stitched, slashed, cut, machine appliquéd, tagged

76"W x 69"H (193 x 175 cm)

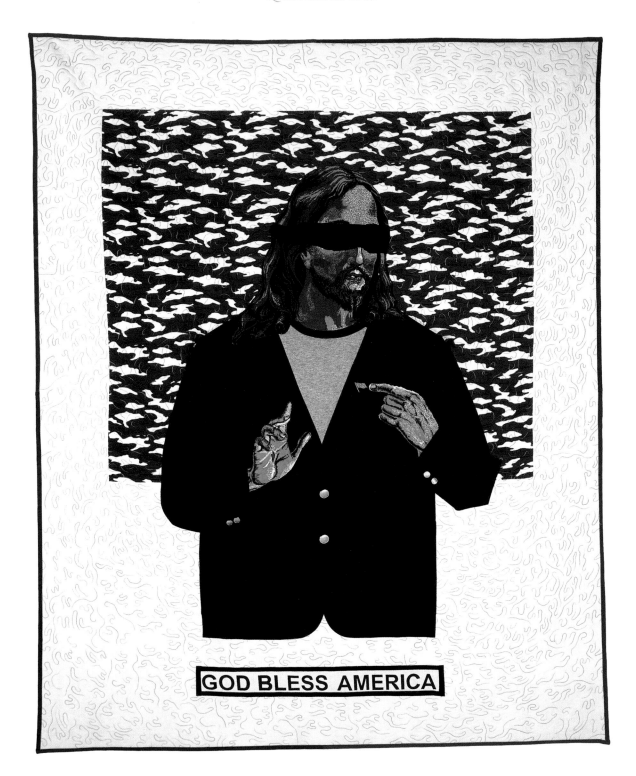

Shawn Quinlan
Pittsburgh, Pennsylvania

I wanted to form my frustration with our political development.

"I have never said that I don't wear flag pins or refuse to wear flag pins. This is the kind of manufactured issue that our politics has become obsessed with and, once again, distracts us from what should be my job when I'm commander-in-chief… "—Barack Obama

God Bless America
2008

Cotton, thrift store sport jacket; machine pieced, appliquéd and quilted

52"W x 65"H (132 x 165 cm)

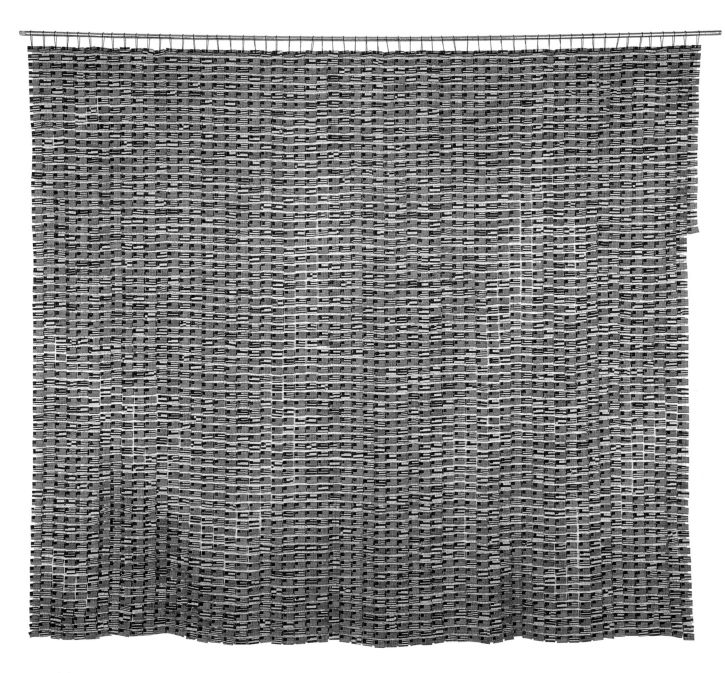

Kathleen Loomis
Louisville, Kentucky

Quilts Japan Prize

As of Memorial Day, May 26, 2008, there were 4,083 U.S. military dead in Iraq. Here is a flag for each of them.

Memorial Day
2008

Cotton; machine stitched

100"W x 86"H (254 x 218 cm)

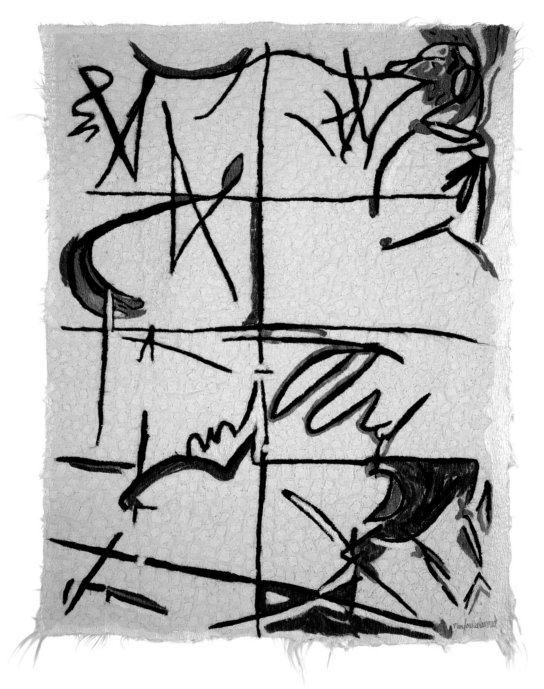

Mary Louise Learned
Boulder, Colorado

*I took my passion for music and movement and applied it
directly to the canvas, using a black wax crayon. My body, arm,
and hand danced "old school" across this surface to the driving
funk sounds of Gap Band. It was an exhilarating experience,
and one I continue to work with.*

Street Dance
2008

Cotton, wool roving, rayon
and linen blend, paint, tencil
roving; whole cloth, direct
raw-edge appliquéd, machine
stitched, needle felted

38"W x 49"H (97 x 124 cm)

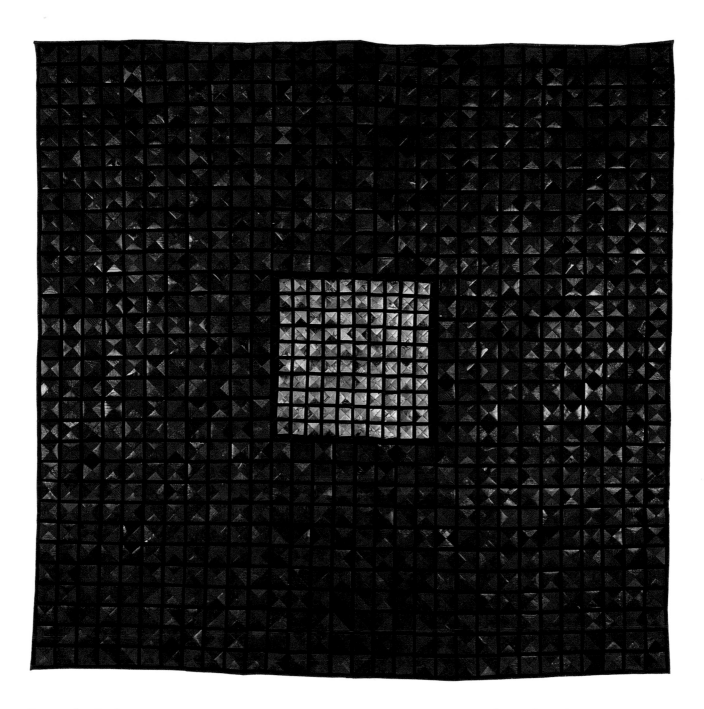

Lucinda Carlstrom
Atlanta, Georgia

*I have been making my paper quilts for over 20 years.
My background in fine art, printmaking, and collage
gave me this idea by accident. I traveled to Japan and
purchased wonderful doll-makers' papers. I recycle
old kimonos and thrift-store dresses to get the many
colors and patterns.*

Mixed Metals with Wine 4,726 Pieces
2007

Japanese paper, silk, gold leaf, patinated
bronze-leaf; hand painted, machine stitched

57"W x 57"H (145 v 145 cm)

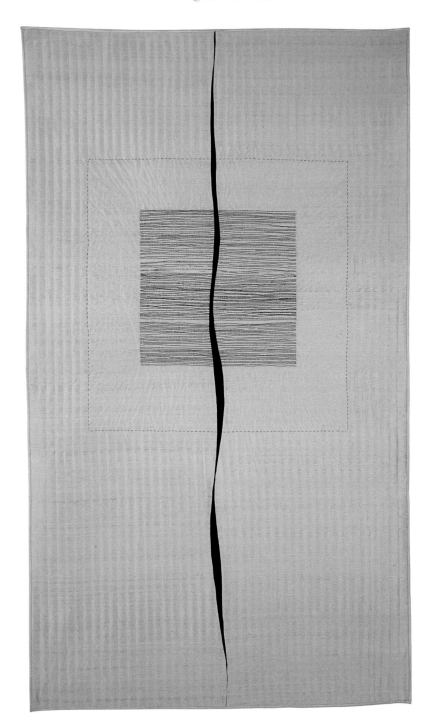

Daphne Taylor
New York, New York

My quilts honor my love of drawing. Lines reminiscent of landscape and structure are embroidered, pieced, and composed within open white spaces. The visual language of these lines is influenced by the power of simplicity. Hand quilting is important in my work because it is the act of drawing and is a loose, spontaneous act. My hand responds to the shapes in the cloth, creating a soft rhythm of shadow that is simple, clear, and meditative.

Quilt Drawing #9
2008

Silk, cotton, cotton embroidery floss, polyester batting; machine pieced, hand embroidered and quilted

33"W x 58"H (84 x 147 cm)

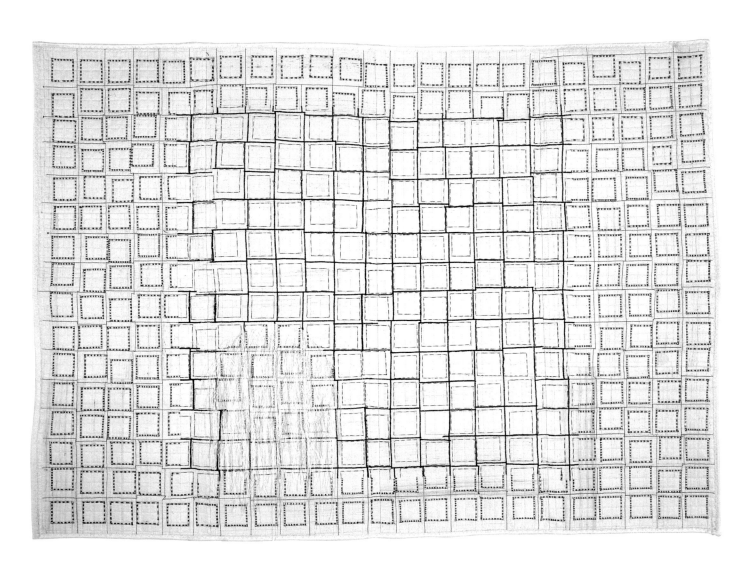

Harue Konishi
Nakano-ku, Tokyo, Japan

It took me so long to get to my own original quilts. Going back to the starting point, I found that I could express myself most effectively using simple colors and techniques. I hope that my life can also be lived simply.

SYO #28
2008

Silk; machine pieced and quilted

52"W x 38"H (132 x 97 cm)

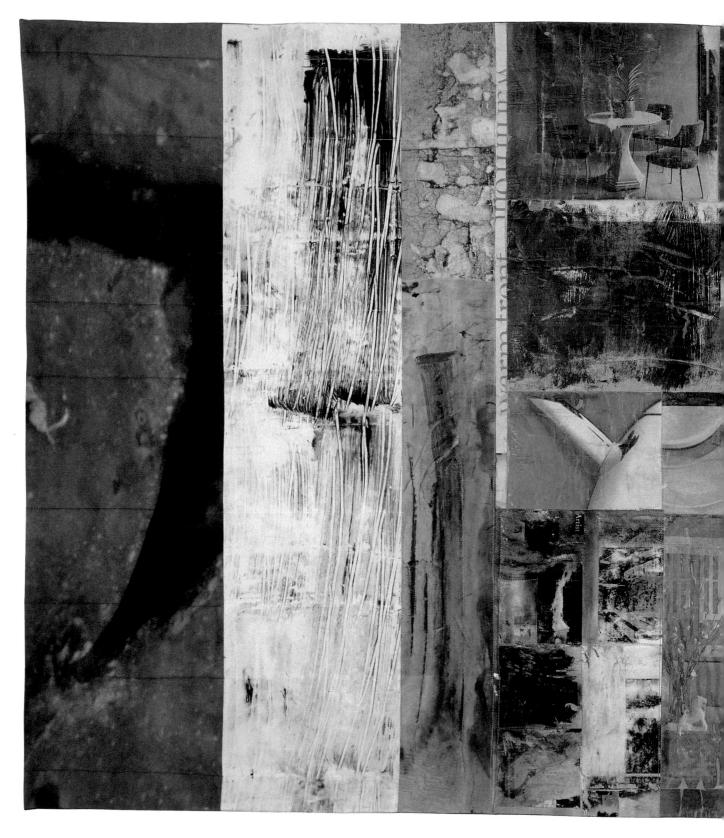

Joan Schulze
Sunnyvale, California

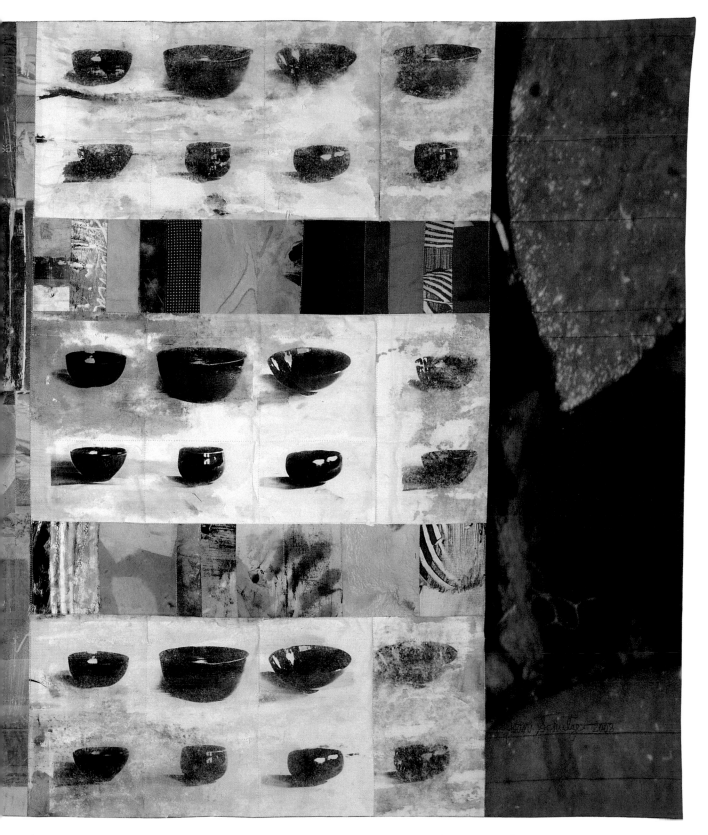

Meditation—Place
2008

Cotton, silk, paper; glue transferred, monoprinted,
digitally printed, pieced, machine quilted

59"W x 30"H (150 x 84 cm)

71

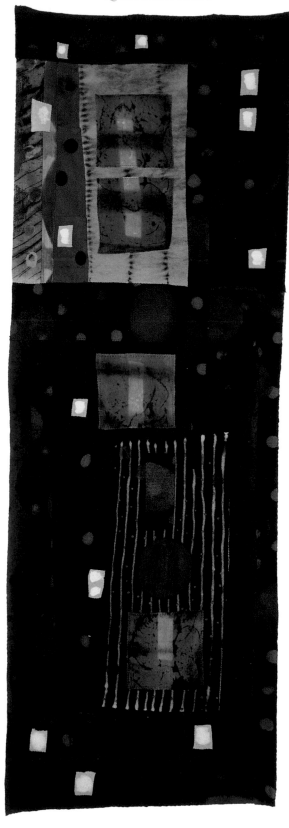

Bonnie Wells
Walnut Creek, California

My work is about the interaction of bold color, primitive pattern, and the shades of feeling that they evoke. I use dyeing techniques that create unpredictable patterns and shapes. This piece is comprised of smaller pieces that are individually dyed and that contain a fine patina of color, revealed in their broken hues and texture. I compose and stitch them together, allowing the larger shape to unfold from the integrity of the individually dyed pieces.

Metaphysic
2006

Wool, acid dye, illuminating dye, discharge medium; painted, printed, appliquéd, shibori dyed, screen-printed, discharged, pieced, stitched

23"W x 70"H (58 x 178 cm)

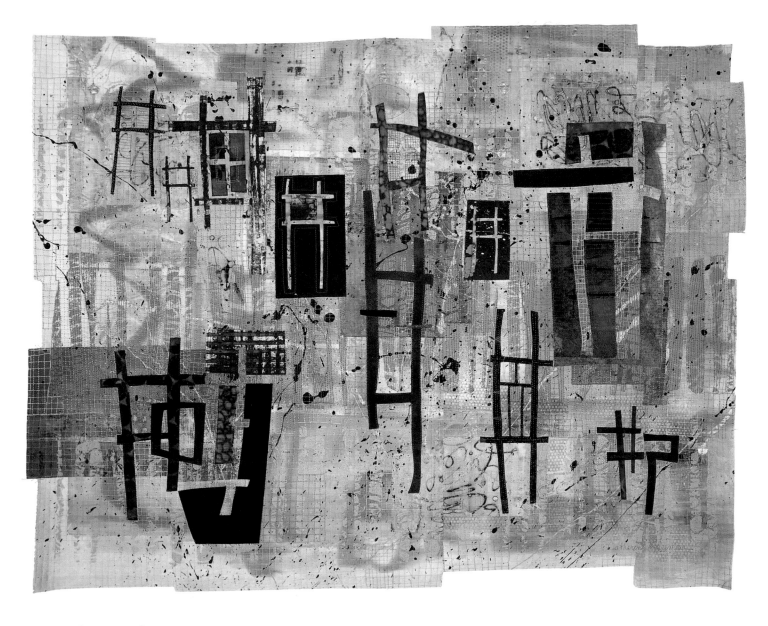

Catherine Kleeman
Ruxton, Maryland

This piece is a continuation of my "Windows" series. Frames, mullions, and transoms create a diversity of interesting forms and become a launching point for endless explorations. Windows are also a metaphor—reality viewed though a window, self-reflected in the window, the truth distorted, intentionally or not. The negative shapes also speak—the unseen, the unspoken, the undone. Family Reunion embodies all of this and more!

Family Reunion
2008

Cotton, dye, paint; screen-printed, painted, fused, direct appliquéd, machine quilted

40"W x 32"H (102 x 81 cm)

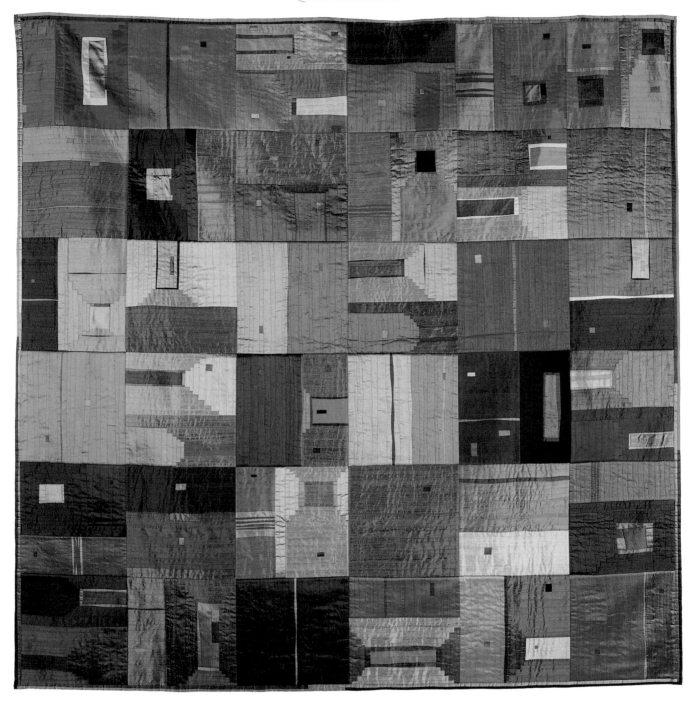

Christine Tedesco
Pendleton, South Carolina

A few years ago I had the opportunity to live in Italy for an extended period of time. I began to notice the beautiful tile work that was everywhere throughout the country. I began to photograph, draw, and make watercolors of these tiles whenever I encountered them, attempting to create a visual library for myself. This study of tile design, in combination with my education in architectural design, has given me a rich vocabulary for my nontraditional textile work. Using vibrant, iridescent silks, I create dynamic compositions inspired by the patterns I saw in Italy. .

Architectural Squares
2008

Silk; machine pieced

72"W x 72"H (183 x 183 cm)

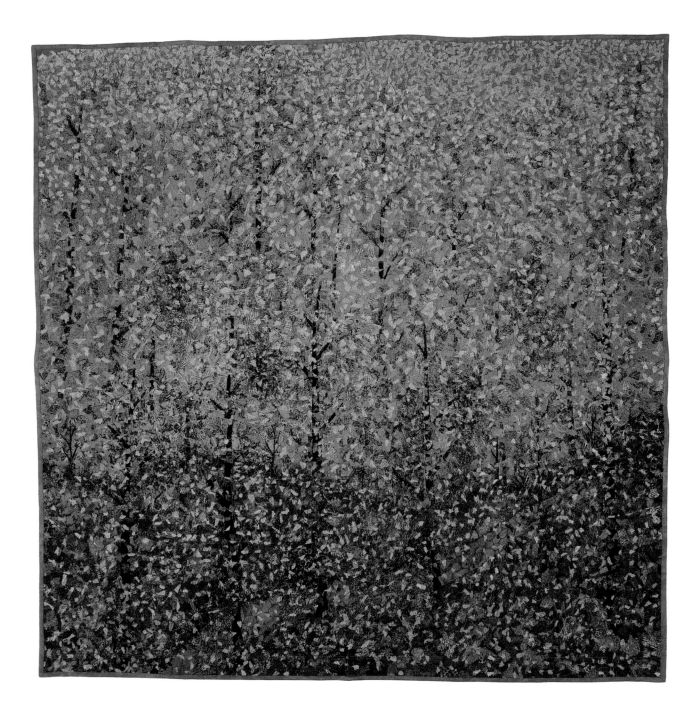

Barbara Oliver Hartman

Flower Mound, Texas

The quilts made using this method started more than 15 years ago and are the end product of all other projects. All bits and pieces are saved, and when they cannot be used in any other way, they are graded by color and used as a painter would use paint.

Falling Leaves
2008

Cotton; free-motion zigzag stitched

41"W x 41"H (104 x 104 cm)

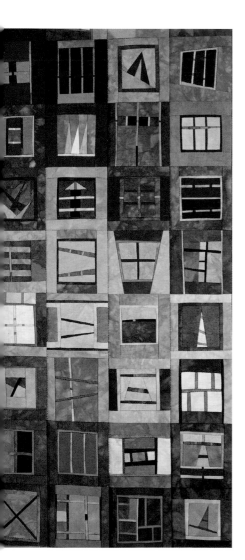

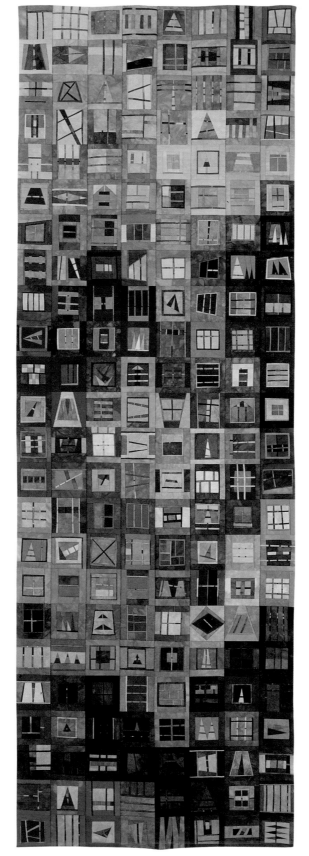

Erin M. Wilson
Brooklyn, New York

Once in a while, it is good to make something of the leftovers. This quilt continues a series focusing on spontaneous design, small scale piecing, and the stories that emerge from abstract compositions of color and shape.

Miscellany
2008

Cotton, dye; machine pieced and quilted

20"W x 61"H (51 x 155 cm)

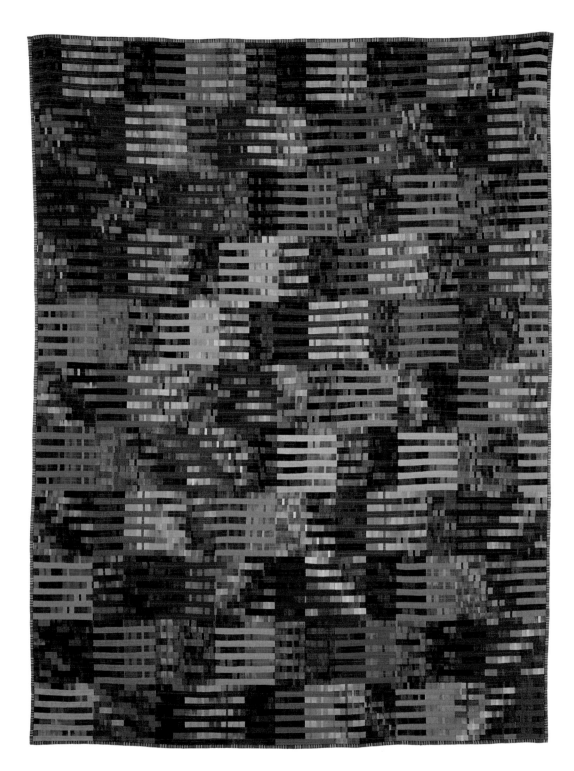

Kent Williams
Madison, Wisconsin

*So, here are these ikat fabrics I bought. And they're
already so damn beautiful. What to do but slice
them to pieces, sew them back together, and make
them part of something I've never seen before.*

Take Five
2007

Cotton; machine pieced
and quilted

60"W x 80"H (152 x 203 cm)

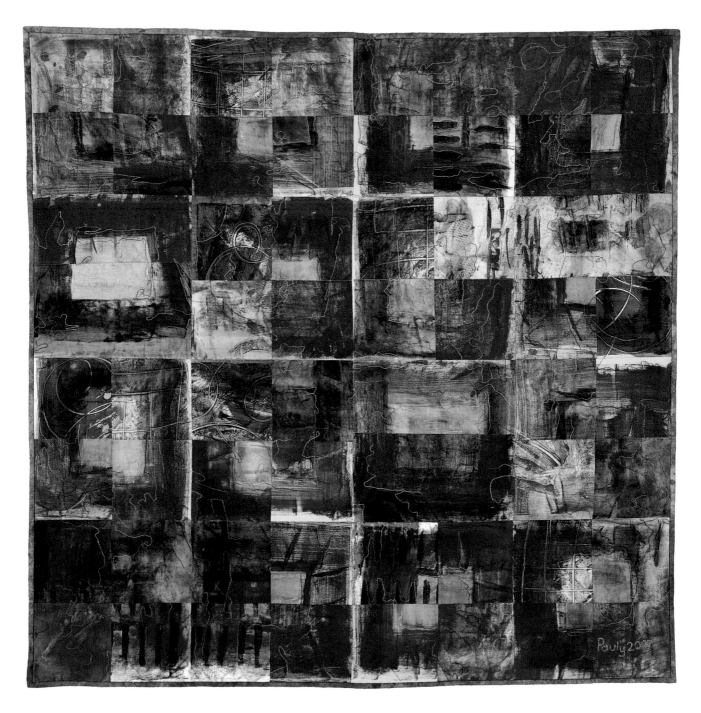

Pat Pauly
Pittsford, New York

This quilt pays homage to the simple four-patch design with painterly techniques. The work is more canvas than quilt.

Painted Squares
2007

Cotton; monoprinted, painted, dye stamped, machine pieced and quilted

45"W x 45"H (114 x 114 cm)

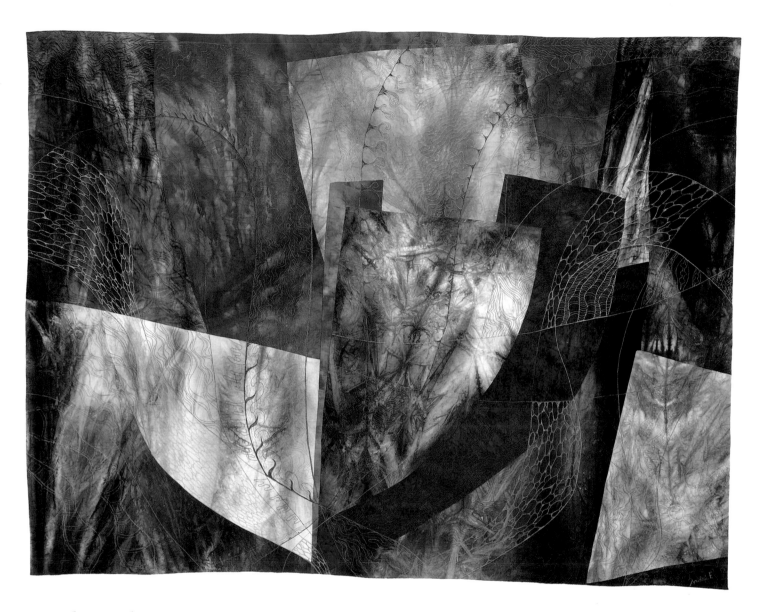

Andrée Fredette

Saturna Island, British Columbia, Canada

*Now that I live on the edge of the continent, I pay attention to
the ebb and flow of the intertidal shore—the border between
land and sea—where countless creatures subsist in a hostile
environment. Even tunicates, a brainless creature, can invade…
moving borders, conflict, survival—the elegant cruelty of life.*

Tunicates #1
2007

Cotton, dye, cotton batting; machine
pieced and quilted

73"W x 56"H (185 x 142 cm)

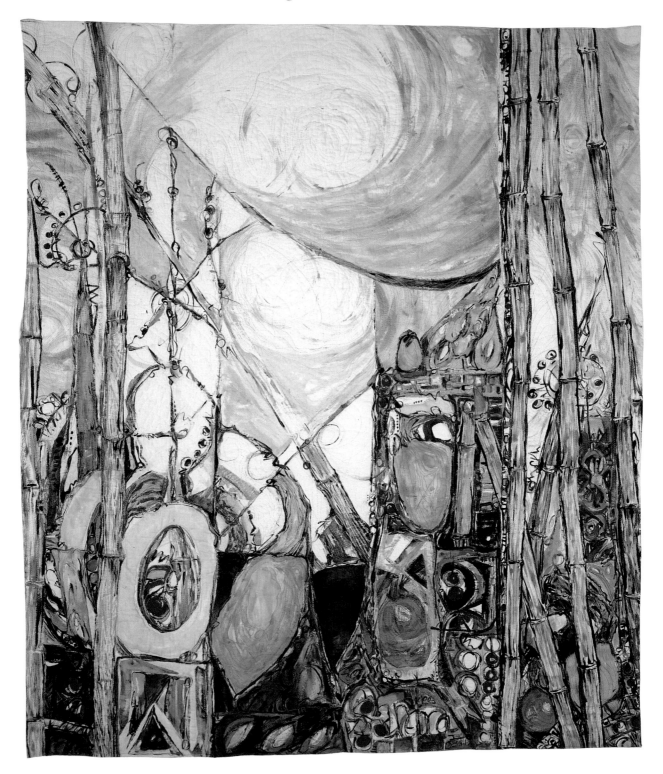

Sandra LH Woock
Bethesda, Maryland

Juror's Award of Merit

Blue Bamboo is my transitional series, using my usual x's and o's in a more literal matter to create my imagery. Living in the DC metro area, I am fascinated by the bamboo that grows wild. Included in my imaginary garden, this prolific plant requires no maintenance to keep it under control and adds a sense of order to nature's chaotic growth.

Blue Bamboo/Blue Breeze
2008

Cotton, cotton batting, polyester and rayon thread; painted, machine pieced and quilted

54"W x 62"H (137 x 157 cm)

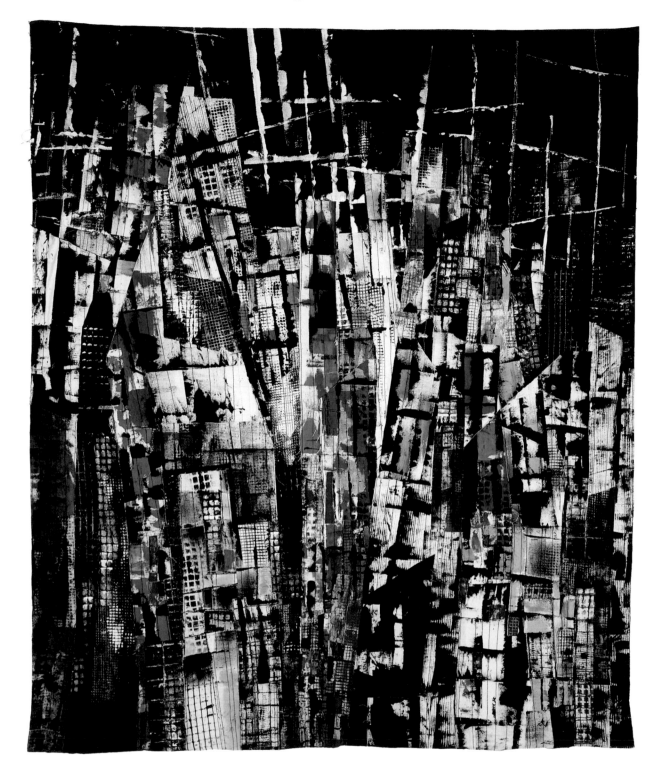

Linda M. Levin
Wayland, Massachusetts

Juror's Award of Merit

This piece is one in a series about my impressions of New York, where so much visual information assaults the eye. The challenge lay in organizing all of it while keeping alive the excitement, the color, the motion.

City With Footnotes VIII
2008

Cotton, cotton/polyester, assorted fabrics, textile paint; machine stitched

40"W x 49"H (102 x 124 cm)

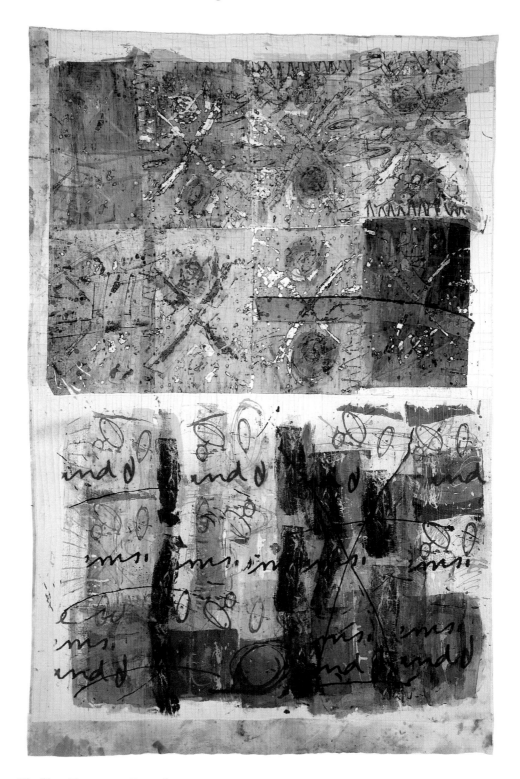

Shelley Brenner Baird
Columbus, Ohio

Fabricate means to dream up, assemble, and create. I create nonliteral narratives—stories told in time and place—by layers and gestures. Marks I make may be balanced or reckless, austere or angry, surgical or ragged, literal or obscure. Images are superimposed on cloth by screen-printing, painting, and drawing—instantaneous and immutable processes that create shapes and vestiges that echo across the surface.

Forest for the Trees
2008

Cotton, silk, dye, paint; screen-printed, painted, monoprinted, machine quilted

44"W x 69"H (112 x 175)

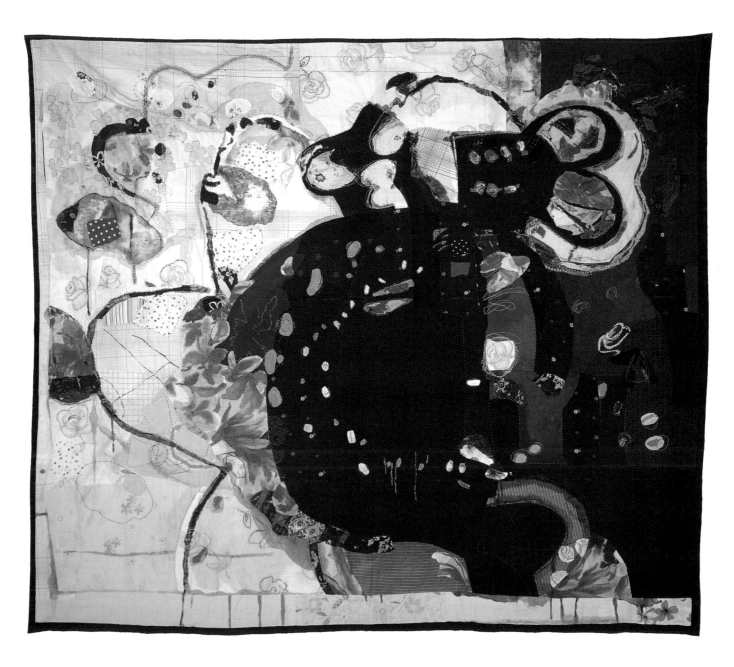

Anne Smith
Warrington, Cheshire, England

Best of Show

The old Welsh hymn "Calon Lân" sings of a pure heart. This quilt is a celebration of contented times, everyday blessings, and simple gifts.

Calon Lân
2008

Recycled fabric; hand pieced and dyed, hand and machine appliquéd, hand embroidered and quilted

58"W x 51"H (147 x 130 cm)

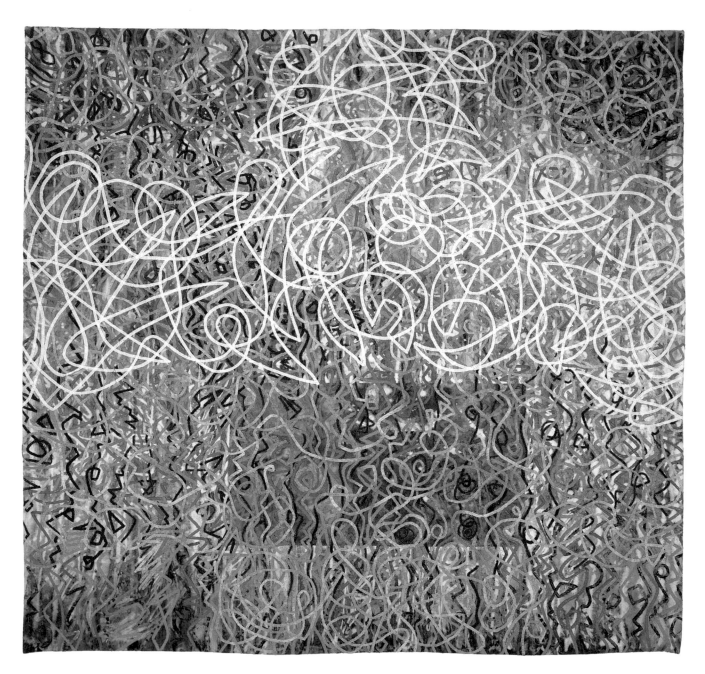

Eileen Lauterborn
Farmingdale, New York

*As a painting is built layer by layer, so too
are my quilts. The fabric strips are applied as
I would apply paint to canvas, then they are
sewn, and the whole composition is quilted.*

Graffiti
2008

Cotton, rayon thread, polyester batting;
fused, appliquéd, embellished, dyed,
discharged

46"W w 42"H (117 x 107 cm)

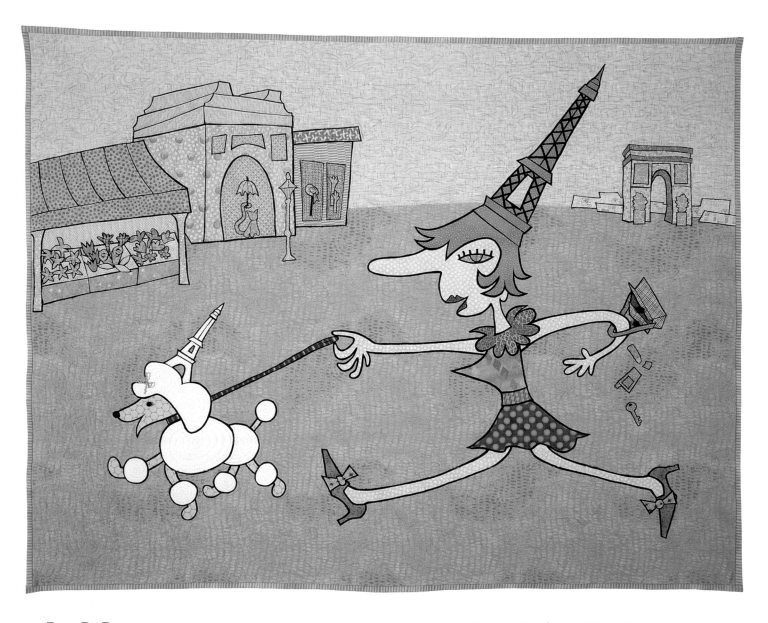

Pam RuBert
Springfield, Missouri

*I believe the true power of art is the
ability to transport us to new or
unexpected places—either real or
only in the artist's mind.*

Paris—Wish You Were Hair
2008

Cotton, dye, vintage buttons; fused, raw-edge
appliquéd, free-motion machine quilted

57"W x 38"H (145 x 97 cm)

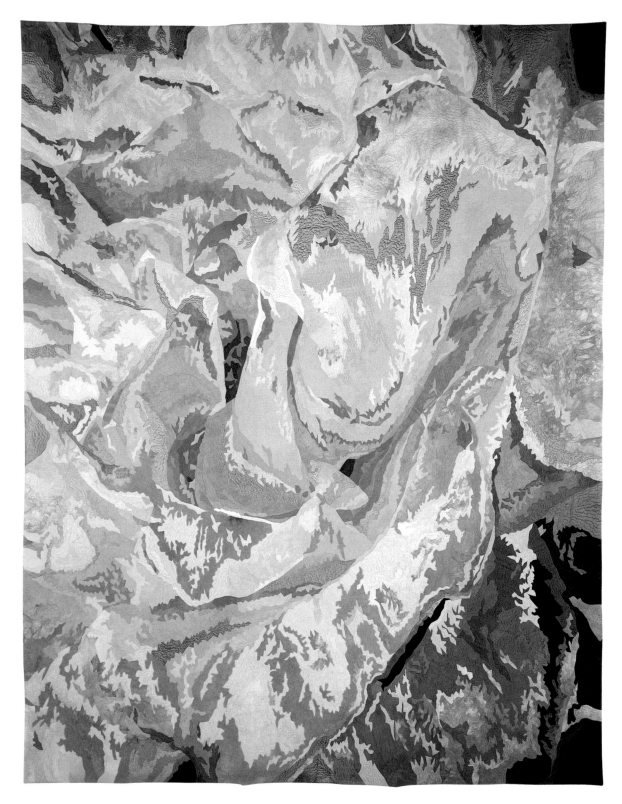

Paula Chung
Zephyr Cove, Nevada

*My gardens provide a source of inspiration and solace.
My pieces try to capture a blossom's essence—its energy.
Through the use of my photographs, a personal message
is sought.*

White Rose XIII
2008

Silk, fusible interfacing, monofilament
thread, cotton, cotton/polyester batting;
machine appliquéd and quilted

54"H x 70"W (137 x 178 cm)

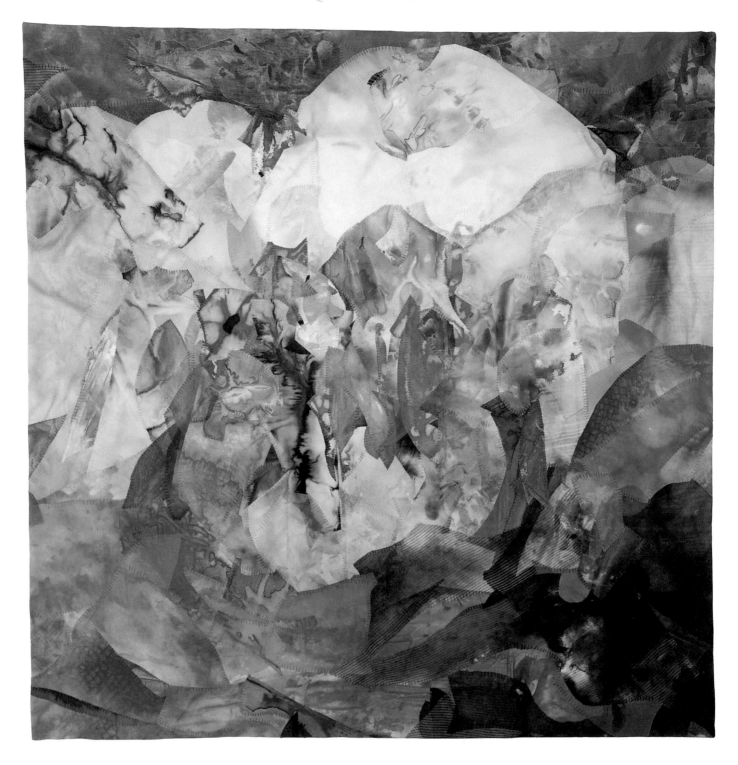

Emily Richardson

Philadelphia, Pennsylvania

The title embodies a sense of both anticipation of the future and reflection and understanding of the present and past. Midway through the process of creating this work, a cohesive composition began to take hold. What I saw gave me the sense of a place or a point in time. As this concept guided the development of the piece, I came to associate a number of contrasts with what was emerging visually.

Until the Day
2007

Silk, acrylic paint; hand pieced and quilted

43"W x 44"H (109 x 112 cm)

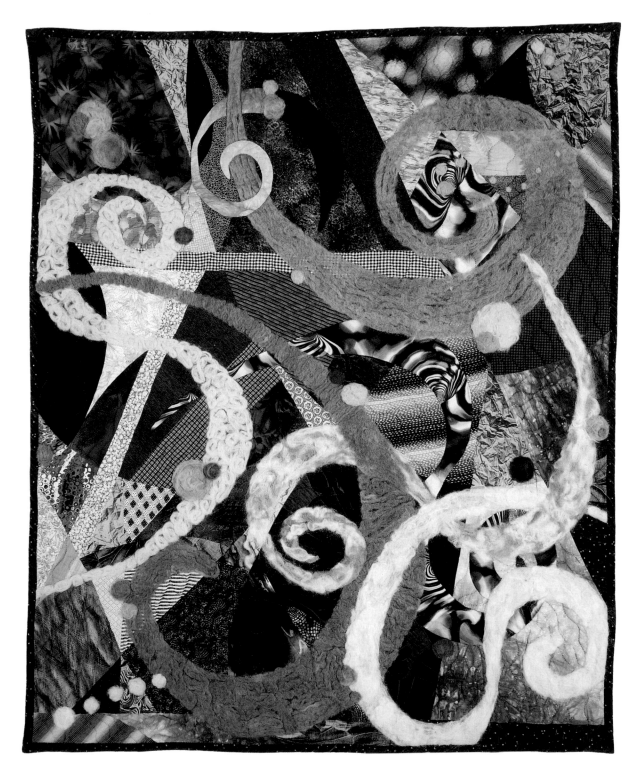

Hsin Chen Lin
Tainan City, Taiwan

There are always conflicts, self-debates, and compromises spinning and spiraling inside human minds. The whirlpool of time makes these spirals more complicated and philosophical. I chose plant-dyed wool to express my expectation of smooth emotion curving along with these spirals of thoughts.

Spirals of Thoughts
2007

Wool, cotton, plant dye; hand pieced and stitched

49"W x 59"H (124 x 150 cm)

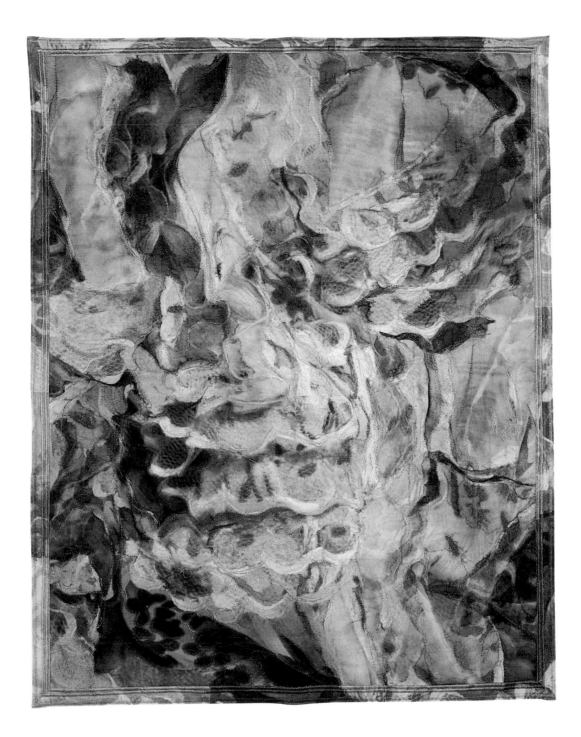

Jessica Jones
Smithville, Tennessee

Through stitched collage I become a cartographer, mapping the surface of the clothing that surrounds me. By digitally printing photographs of clothing, the layered pattern and embellishment of a blouse become topographic marks. The printed imagery of fabric and the actual fabric on which it is printed create a trompe l'oeil effect, confusing what is real or illusory, what is an intimately familiar texture or a mysteriously distant landscape.

Ruffled
2006

Cotton, silk gauze, silk chiffon, silk organza, cotton batting, netting; digitally printed, collaged, machine embroidered

27"W x 34"H (69 x 86 cm)

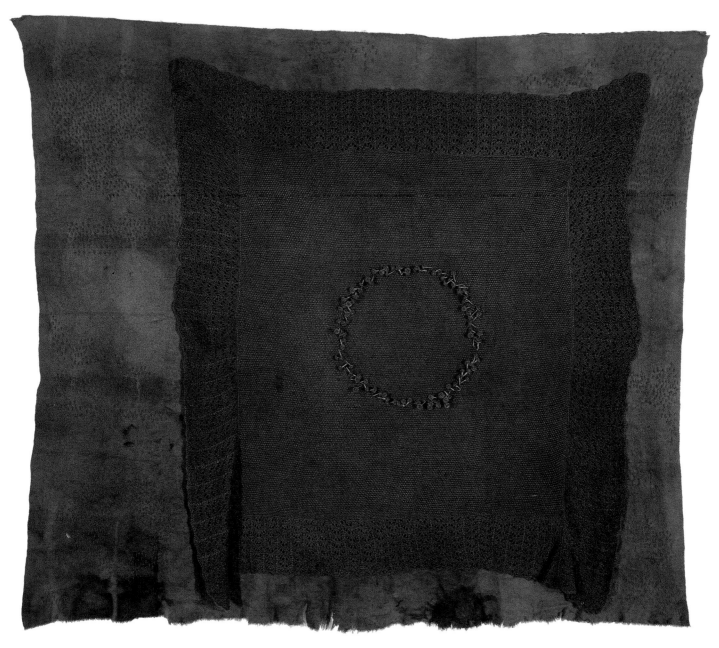

Glenys Mann
Tamworth, New South Wales, Australia

*Finding a plastic, flowered, white wreath at a memorial site
for a young person who had drowned made me think about
the use of the wreath icon as a memorial for those who
had died. Just beyond this memorial was another that had
a similar wreath molded into the headstone dated 1867.
More than 140 years earlier, the wreath image was used to
denote the passing of another spirit in the same spot.*

Horizons #61: Memorial
2007

Wool blanket, knitted-wool baby
shawl, silk thread, silk roses,
plant dye; appliquéd, hand knit-
ted and stitched

60"W x 52"H (152 x 132 cm)

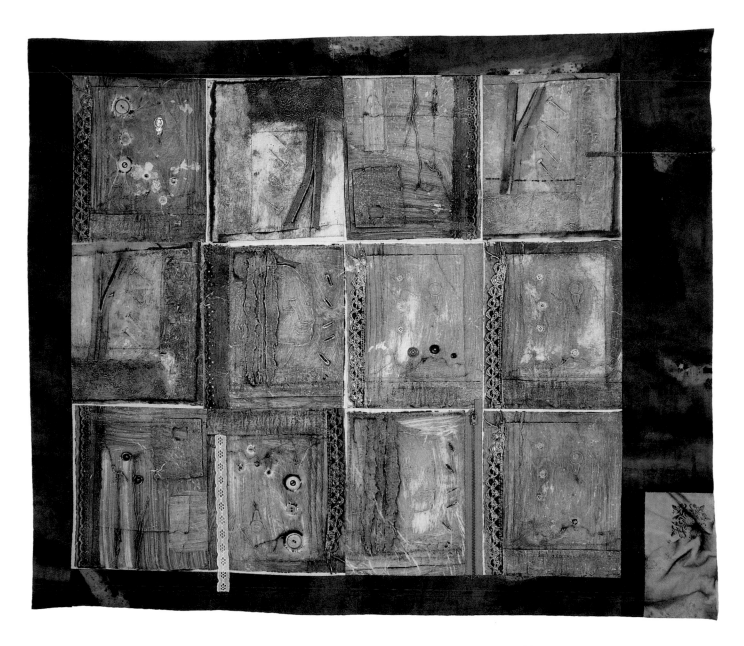

Liz DeBellis
North Canton, Ohio

Hilary Morrow Fletcher
"Persistence Pays" Award

In art my two greatest loves are quilting and printmaking. The combination of these two different media represents the demand for duality in women of the 21st century. On one hand we are asked to be strong, precise, and objective, while at the same time to be domestic, soft, and motherly. Daily we are asked to juggle. Some days we can integrate these qualities flawlessly, and other days these two incredibly different worlds collide.

Self Portrait
2007

Cotton, paint, buttons, zipper, needle threader, lace, beads; collograph printed, machine pieced, hand quilted

43"W x 36"H (109 x 91 cm)

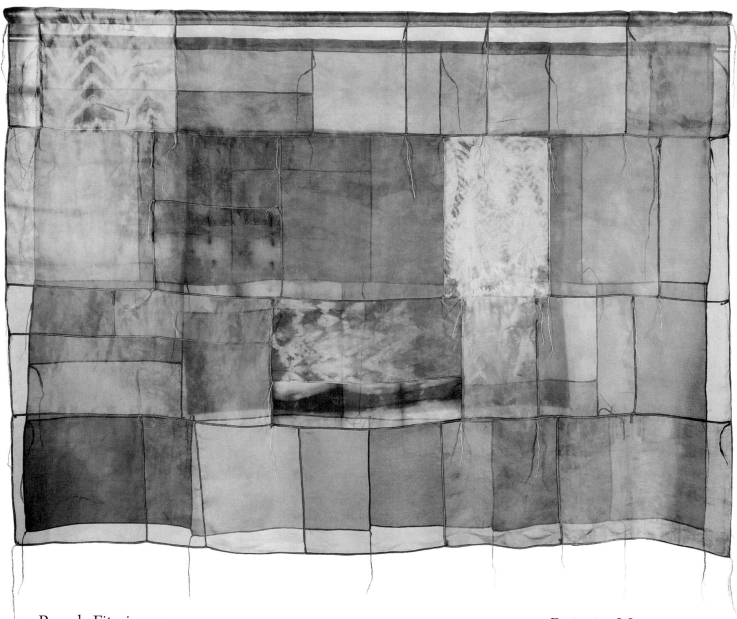

Pamela Fitzsimons
Mount Vincent, New South Wales, Australia

Wrap… enclose… enfold. Australia leads the world in mammal extinctions—28 species since the European settlement 220 years ago. One in five of our remaining mammals is in danger of dying out. The primary cause is habitat destruction—clearing of native forests for agriculture and urban development. Extinction Wrap—28 pieces per panel—references the possum-skin cloak, or wrapping cloth, made in the past by our indigenous people, the Korean Pojagi, and mourns our lost species.

Extinction Wrap
2008

Silk, rayon, and cotton thread; plant dyed, machine pieced, hand stitched

59"W x 44"H (150 x 112 cm)

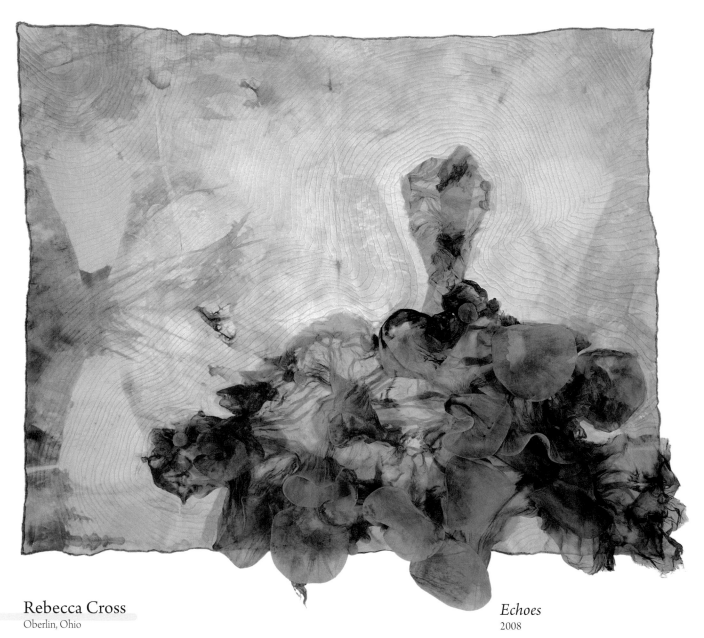

Rebecca Cross
Oberlin, Ohio

Echoes provides a rich metaphor for memory and erasure, serving as a palimpsest for the additive and subtractive processes embedded in it. The head echoes the repeated pattern in the ground, quilted stitching echoes the figure, and the layering and manipulation of materials and color reinforce these concepts. Silhouettes have great expressive potential. The shibori shape-resists create a translucent, organic ground out of which the figure emerges, describing a complex, specific context through which this figure communicates.

Echoes
2008

Silk habotai, silk organza, nylon and cotton thread, fusible web, cotton batting; dyed, shibori shape- and clamp-resisted, machine stitched, fused

42"W x 37"H (107 x 94 cm)

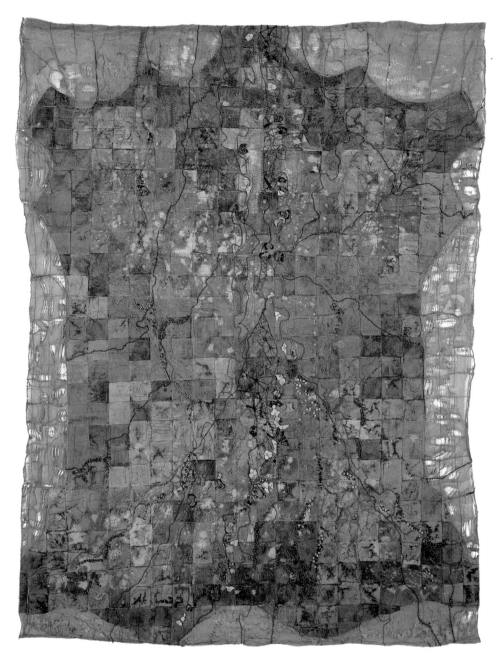

Sue Akerman

Pietermaritzburg, KwaZulu-Natal, South Africa

Most Innovative Use of the Medium

I have always been intrigued with aerial views—the scars we humans make on our planet and on things around us. I have vivid memories as a little girl of cows being branded—scarred for life. Humans, for greed and self gratification, will ride roughshod over everything, not worrying about the end result or the marks they make and leave. Be gentle on this place!

Africa Scarified IV
2008

Organza, teabags, cotton, cotton batting, beads; machine and hand embroidered, machine and hand stitched

56"W x 67"H (142 x 170 cm)

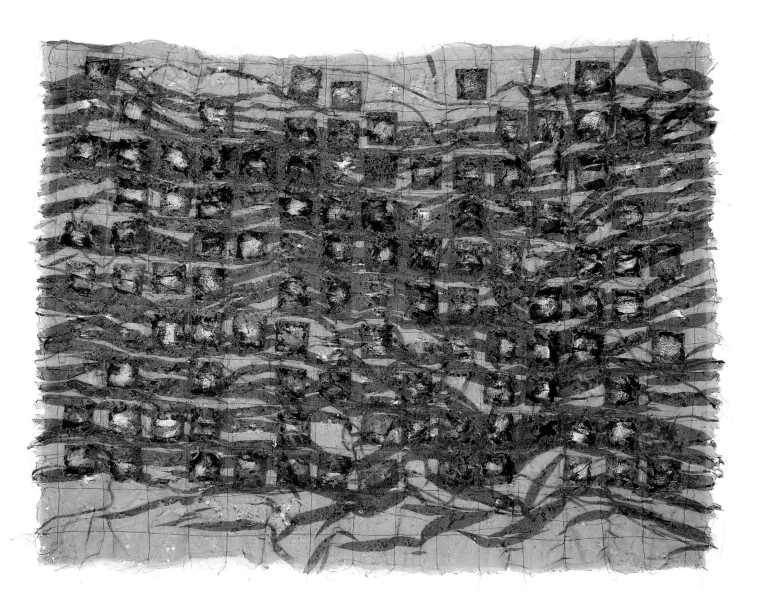

Alison Schwabe
Carrasco, Montevideo, Uruguay

Natural forces and the efflux of time are the twin agents of change, producing marks and scars on the physical world. These patterns I term Timetracks.

Timetracks 7
2008

Cotton, nylon organza, metallic thread, leather, metallic wax; machine quilted, burned, waxed

37"W x 29"H (94 x 74 cm)

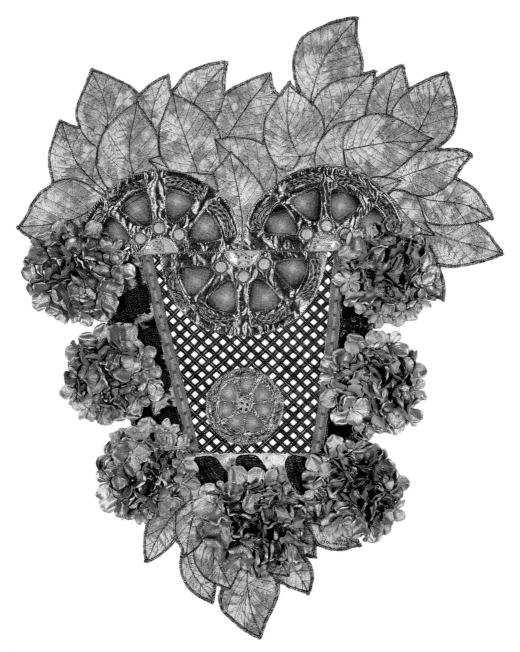

Christine Milton
Oldsmar, Florida

This work is the product of a collage designed from photos of plantings at our cottage and photos of parts of my car. I printed them out in black and white, cut out various interesting elements, and formed this design. In this day and age, when we are concerned about protecting the environment, it is my hope that we can conduct our industrial pursuits while still balancing the needs of nature. This work hopefully reflects that vision.

When Nature and Industry Collide
2008

Cotton, silk, blends, paint, glue; painted, glued, pieced, appliquéd, fused

22"W x 28"H (56 x 71 cm)

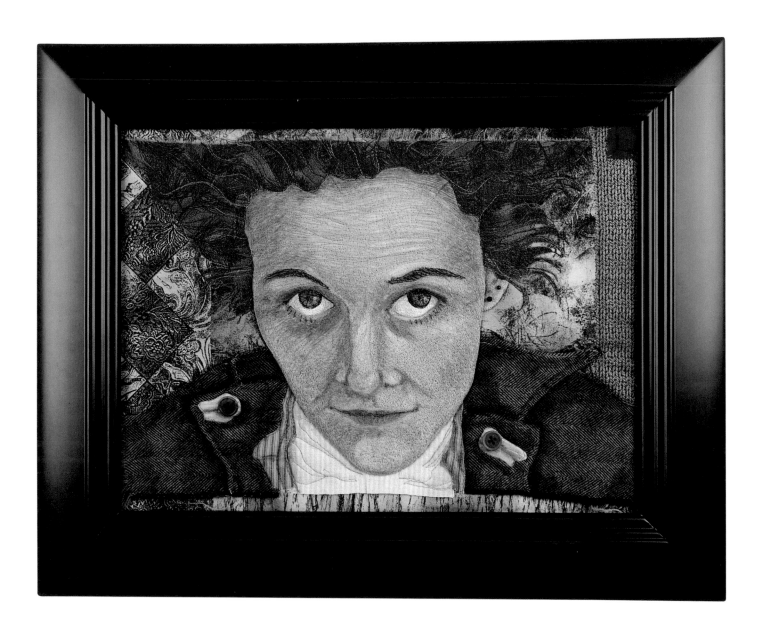

Lora Rocke
Lincoln, Nebraska

Experimentation has lead me to try many needle arts, finally landing me at a quiltmaker's doorstep. My entire focus as a quilt artist has been to share specific times and personal events that express the powerful, playful beauty of memory. The piece you are viewing was created after my friend and mentor died of ovarian cancer. At her memorial I discovered that she was known by many names.

Kathryn, Kathy, Katie, Kate
2007

Cotton, wool, cotton and rayon-blend thread, buttons, beads, cotton batting; hand and machine appliquéd and stitched, machine quilted

16"W x 14"H (41 x 36 cm)

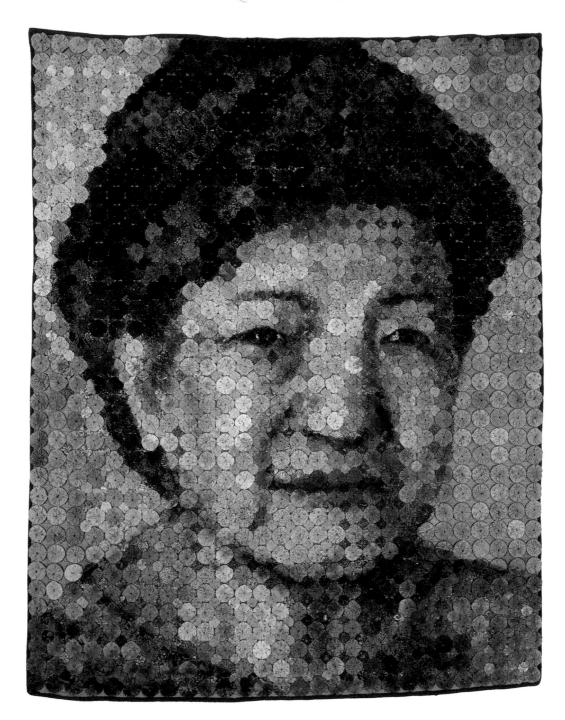

Shin-hee Chin
McPherson, Kansas

Through this series of pieces, I wanted to highlight the interconnected-ness of humankind—that humanity constitutes one family. I began portraits of my family, but expanded by including marginalized and forgotten people. In (Choon San) Spring Mountain—a portrait of my mother—I wanted to depict an Asian woman who has remained faceless and voiceless, sacrificing for family. I wanted to convey her vitality through a floral pattern—like mountains in the spring—alluded to her in name. Through this work, I wanted to give her a face and a voice.

(Choon San) Spring Mountain
2008

Recycled fabric, dye, fabric paint; dyed, painted, hand stitched

50"W x 63"H (127 x 160 cm)

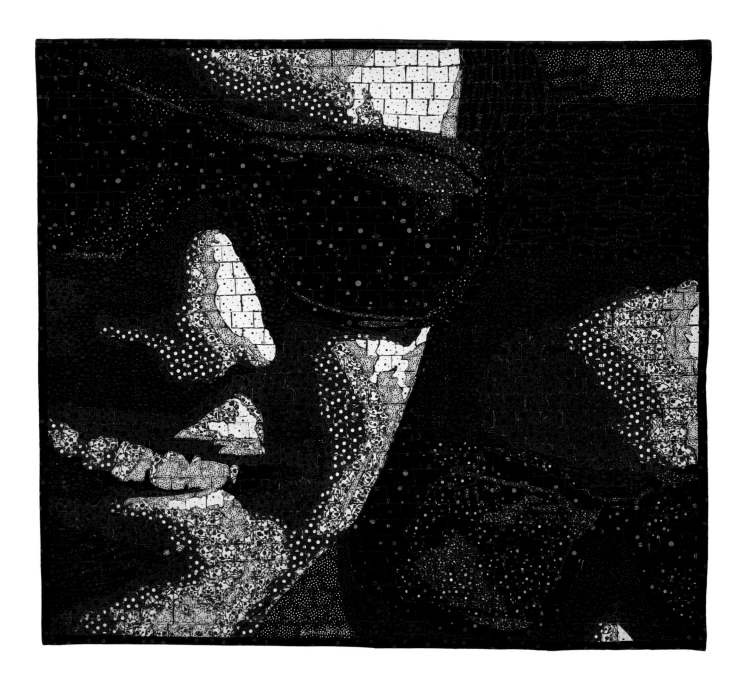

Kathleen McCabe
Coronado, California

*We often find ourselves in another person's
shadow. It may be literally, figuratively,
emotionally, professionally, or in our family,
our relationships, or our careers. Are you in
someone's shadow?*

In His Shadow
2008

Cotton, tulle, batting, thread;
machine raw-edge appliquéd,
machine quilted

33"W x 29"H (84 x 74 cm)

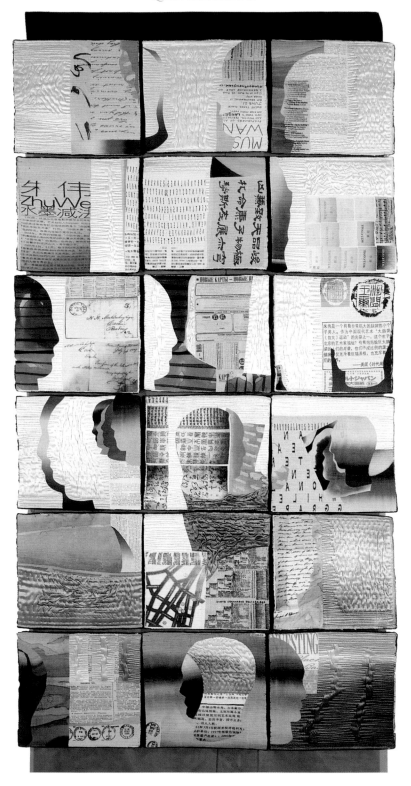

Ludmila Uspenskaya
New York, New York

Day after day do we find or waste?
Moving forward or backward?
And what is our haste? Who does inform us?
And what is this we?
Yet not once have we stopped in our longing to be…

Day to Day
2008

Silk, cotton; hand painted, wax resisted, collaged, photo transferred, machine and hand quilted

41"W x 92"H (104 x 234 cm)

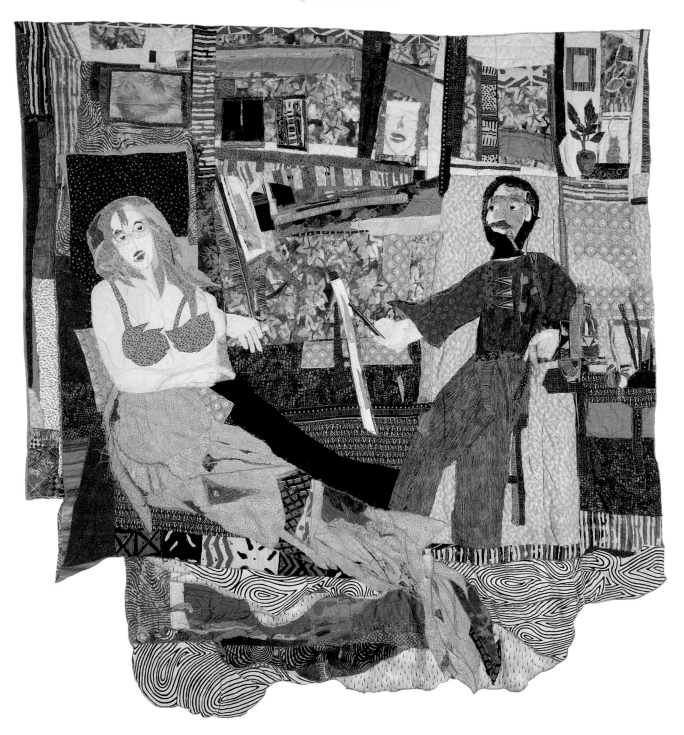

Cathy Jeffers
Centerville, Ohio

I was inspired by famous "artist and model" paintings for this quilt. The artist has painted the mermaid many times, but he is never able to capture her beauty. The mermaid, shown with a sour face, is annoyed to continue to pose. She is likely to slip away. Together they create a world of opposites drawn together by beauty, inspiration, and a purpose.

The Artist and the Mermaid
2008

Synthetic fibers, mesh, floral mesh, wire, toile, dye; machine pieced, fused and appliquéd, hand pieced, machine quilted

72"W x 87"H (183 x 221 cm)

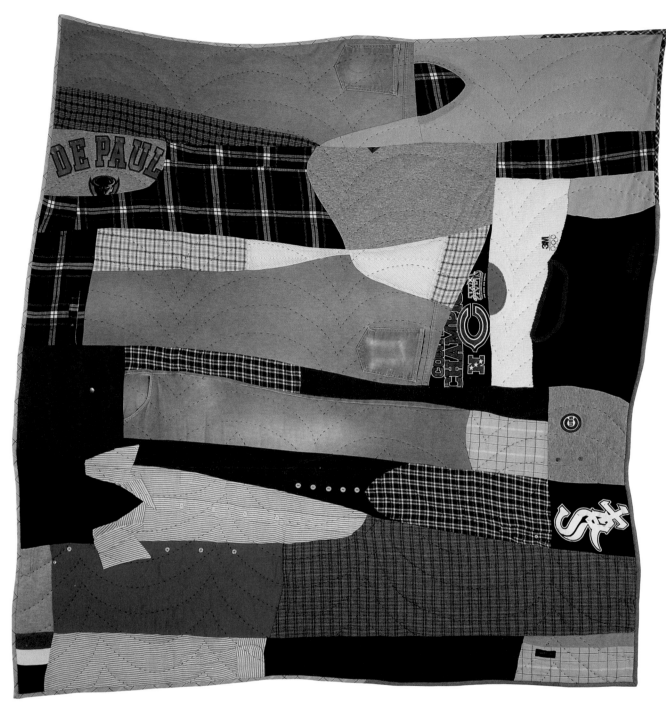

Sherri Lynn Wood
San Francisco, California

I work with people to make improvisational quilts from the clothing of the deceased. In my practice, a "Passage Quilt" is an active, hands-on context for bereavement and transformation. Debbie Piscitelli, the daughter of Ronald J. Tworek, brought her father's clothing and helped me cut it apart as she shared stories of his life and death. The resulting quilt reflects relationships, retains a sense of the body, and carries the consoling essence of the beloved.

(Quilt graciously loaned by the family for exhibition.)

Ronald J. Tworek (1935–2007)
2008

Clothing; hand and machine pieced, hand quilted

65"W x 68"H (165 x 173 cm)

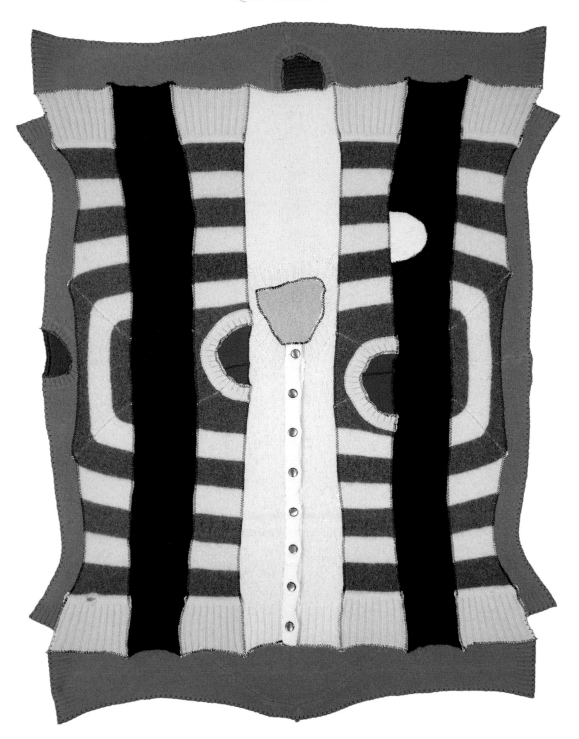

Ellen Zak Danforth
Fort Collins, Colorado

This piece is one in a series of "bar quilts." I am experimenting with a seemingly endless variety of bar compositions, based loosely on the traditional bar quilt. I think of them as visual puns. Parallel Bars refers to the mental gymnastics required when trying to understand something more complicated than it seems.

Parallel Bars
2008

Recycled wool sweaters; felted, pieced, appliquéd, hand quilted

33" W x 42" H (84 x 107 cm)

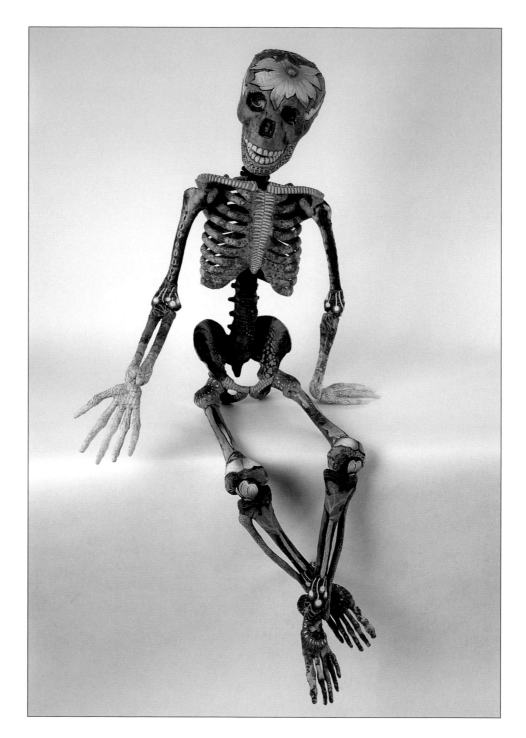

Susan Else
Santa Cruz, California

I like to conflate contradictory ideas in my work—life/death, fear/festivity, reason/terror, flowers/bones, conversations/silence. The universe is an odd and wonderful mélange.

Nothing to Fear
2008

Cotton, paint, dye, armature (commercial plastic skeleton); reverse direct- and machine-appliquéd, machine quilted, hand sewn

30"W x 49"H x 27"D (74 x 124 x 69 cm)

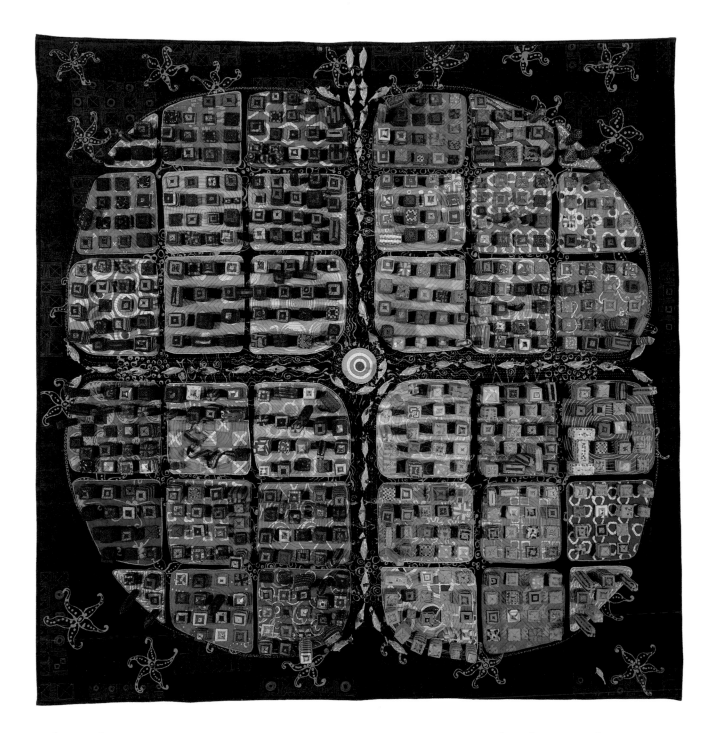

Kathy York
Austin, Texas

As global warming runs amok, the ocean threatens our highly populated, low lying communities; yet, we are still dependent on it for sustenance. The taxi-fish are a metaphor for our dependence on the ocean and, by proxy, our need to protect it. This quilt is dedicated to the little fish—the environmental refugees looking for a new place in a new world.

Little Fish in a Big City
2008

Cotton, silk organza, interfacing, polyester stuffing, fabric paint, Guatemalan worry dolls, batik fabric, shibori fabric; discharged, dyed, screen-printed, machine pieced and quilted, appliquéd, hand quilted and embellished

57"W x 58"H x 6"D (145 x 147 x 15 cm)

About the Dairy Barn

Over the past 30 years, the Dairy Barn Arts Center has evolved into a first-class arts center with 6,000 square feet of exhibition space. Renovation architects retained the original character of the barn without sacrificing the design, climate control, or security features that make it a state-of-the-art, accessible, cultural facility. In 1993 the Ann Howland Arts Education Center was built to house The Dairy Barn's growing art-class and workshop program. A capital campaign led to the 2001 renovation and expansion of an additional 7,000 square feet previously undeveloped on the second floor. The space now includes five rooms for performing- and visual-arts classes and community events.

The mission of the Dairy Barn Arts Center is to nurture and promote area artists and artisans, develop art appreciation among all ages, provide the community access to fine arts and crafts from outside the region, and to draw attention and visitors to southeast Ohio. The twelve-month program calendar includes international juried exhibitions, touring exhibits, festivals, regional-interest programs, live performances, and activities for all ages. Some events are produced entirely by the Dairy Barn Arts Center, while others are the result of cooperation with regional education, art, or community organizations. Exhibits such as OH+5 and Athens Voices feature outstanding regionally produced artwork in a variety of media. The Dairy Barn Arts Center has also developed an international reputation for excellence with Quilt National—a biennial exhibition that has attracted more than 100,000 visitors to Athens from around the world since its premiere in 1979.

The Dairy Barn Arts Center is supported by admissions, memberships, corporate sponsorships, art sales, exhibition tours, and grants. Assisting the full-time staff of seven is a corps of more than 200 volunteers who donate thousands of hours annually.

Its top-notch exhibitions and programs, its reputation in the international arts community, its close proximity to Ohio University, and its picturesque setting make it an important stop on the itinerary of many visitors. The Dairy Barn Arts Center has added significantly to the reputation of the Athens area as a cultural center. Both Athens and the Dairy Barn have been featured in the book The 100 Best Small Arts Towns in America, and Athens was mentioned in USA Today as one of the 10 best arts-centered communities in the country.

For a calendar of events and information about Dairy Barn programs, contact the Dairy Barn Arts Center, P.O. Box 747, Athens, OH 45701; phone, 740-592-4981; or visit the website at www.dairybarn.org.

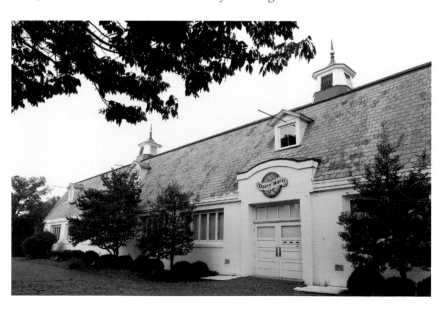

Photo © Gary J. Kirksey

Quilt Tour Itinerary

The complete Quilt National '09 collection will be on display from May 23 through September 7, 2009, at the Dairy Barn Arts Center, located at 8000 Dairy Lane, Athens, Ohio. Three separate groups of Quilt National '09 works (identified as Collections A, B, and C) will then begin a two-year tour to museums and galleries. Tentative dates and locations are listed below. It is recommended that you verify this information by contacting the specific host venue prior to visiting the site.

For an updated itinerary, including additional sites, or to receive information about hosting a Quilt National touring collection, contact the Dairy Barn Arts Center.

P.O. Box 747, Athens, OH 45701
Phone: 740-592-4981
E-mail: artsinfo@dairybarn.org
Internet sites: www.dairybarn.org; www.quiltnational.com

5/23/09–9/7/09 Athens, OH; Dairy Barn Arts Center

9/25/09–10/29/09 St. Charles, MO; The Foundry Art Centre (A, B, and C)

11/12/09–1/17/10 Columbus, OH; The Riffe Gallery (C)

4/8/10–4/11/10 Lancaster, PA; Quilters' Heritage Celebration (A and B)

6/17/10–8/10/10 Paducah, KY; The National Quilt Museum (Museum of the American Quilter's Society) (C)

3/31/11–4/3/11 Lancaster, PA; Quilters' Heritage Celebration (C)

Index of Artists

Shulamit Liss
Yokneam, Moshava, Israel
Page 53

Jane Lloyd
Ballymena, County Antrim, Northern Ireland
Page 21

Kathleen Loomis
Louisville, Kentucky
Page 65

Glenys Mann
Tamworth, New South Wales, Australia
Page 90

Katie Pasquini Masopust
Santa Fe, New Mexico
Page 12

Inge Mardal
Chantilly, France
Page 57

Kathleen McCabe
Coronado, California
Page 99

Aaron McIntosh
Richmond, Virginia
Page 55

Christine Milton
Oldsmar, Florida
Page 96

Patricia Mink
Johnson City, Tennessee
Page 35

Dominie Nash
Bethesda, Maryland
Page 41

Pat Pauly
Pittsford, New York
Page 78

Judith Plotner
Gloversville, New York
Page 42

Clare Plug
Maraenui, Napier, New Zealand
Page 56

Elizabeth Poole
Garrison, New York
Page 58

Shawn Quinlan
Pittsburgh, Pennsylvania
Page 64

Leisa Rich
Atlanta, Georgia
Page 49

Emily Richardson
Philadelphia, Pennsylvania
Title page, page 87

Lora Rocke
Lincoln, Nebraska
Page 97

Pam RuBert
Springfield, Missouri
Front flap, page 85

Judy Rush
Bexley, Ohio
Page 43

Maya Schonenberger
Miami, Florida
Page 45

Joan Schulze
Sunnyvale, California
Pages 70–71

Alison Schwabe
Carrasco, Montevideo, Uruguay
Page 95

Anne Smith
Warrington, Cheshire, England
Back cover, page 83

Ginny Smith
Arlington, Virginia
Pages 50–51

Jen Swearington
Asheville, North Carolina
Page 32

Carol Taylor
Pittsford, New York
Page 30

Daphne Taylor
New York, New York
Page 68

Christine Tedesco
Pendleton, South Carolina
Page 74

Karina Thompson
Birmingham, West Midlands, United Kingdom
Page 63

Ludmila Uspenskaya
New York, New York
Page 100

Nelda Warkentin
Anchorage, Alaska
Page 26

Barbara W. Watler
Hollywood, Florida
Page 18

Bonnie Wells
Walnut Creek, California
Pages 72

Ned Wert
Brush Valley, Pennsylvania
Page 14

Kent Williams
Madison, Wisconsin
Pages 7, 77

Erin M. Wilson
Brooklyn, New York
Back cover, page 76

Sandra LH Woock
Bethesda, Maryland
Title page, page 80

Sherri Lynn Wood
San Francisco, California
Page 102

Kathy York
Austin, Texas
Page 105